IMAGES
of America

PHOTOGRAPHS FROM THE NEWARK HISTORICAL SOCIETY

On the Cover: Newark's train station, serving the Philadelphia, Wilmington & Baltimore Railroad, was constructed in 1877. This image was taken by local photographer Ed Herbener in the 1910s. The station closed in the 1970s but was purchased by the City of Newark in 1986 and renovated in 1988. Today, the building houses the Newark Historical Society and Museum. (Courtesy of the Newark Historical Society.)

IMAGES
of America

PHOTOGRAPHS FROM THE
NEWARK HISTORICAL
SOCIETY

Theresa Hessey

ARCADIA
PUBLISHING

Published by Arcadia Publishing
Charleston, South Carolina

Printed in the United States of America

Library of Congress Control Number: 2021937214

For all general information, please contact Arcadia Publishing:
Telephone 843-853-2070
Fax 843-853-0044
E-mail sales@arcadiapublishing.com
For customer service and orders:
Toll-Free 1-888-313-2665

Visit us on the Internet at www.arcadiapublishing.com

Dedicated to the memory of my father, Robert Hessey, as always

CONTENTS

Acknowledgments

I would like to thank past and present members of the Newark Historical Society's Board of Directors for their enthusiasm for this project. Members of the Newark History Museum's Collections Care Team have done an incredible amount of behind-the-scenes work that made compiling this volume much easier. This book would not have been possible without the generosity of all of those who have donated materials and artifacts that document the history of Newark to the historical society. All images in this volume come directly from this extensive collection unless otherwise noted.

I am especially grateful to Mary Torbey, museum curator, for her passion for Newark history and willingness to answer my many questions. She provided historical and editorial guidance when needed and corrected many errors. This book is much better because of her.

The University of Delaware Library, Museums and Press has digitized and made freely available issues of many Delaware newspapers. Digitized versions of the *Newark Post* were especially helpful in providing background research into many of Newark's residents and businesses. Thanks are due to my colleagues, the library staff who made these materials available.

Thanks are also due to my family, especially Megan Gaffney, who has been my best editor, critic, and sounding board and has always supported me without question. Thank you to my mother, Pat Hessey, and sister Patty Landreth for being my biggest (and loudest) cheerleaders. Finally, I am grateful for my children Riley and Lucas, who put up with mini history lessons on a regular basis with their usual good humor and laughter. You two are my favorites.

INTRODUCTION

Sometimes named "New Ark" in early documents, the City of Newark, Delaware, began as a small farming community. As settlers arrived from Europe, the population began to expand in the early 18th century. A central street, Newark Street, appears on maps as early as 1736 and later became Main Street. The village received a charter from King George II in 1758 and continued to grow as farms, mills, religious institutions, and small businesses were established. The history of Newark is tied to the growth of various industries and the founding of the institution that would later become the University of Delaware. This book chronicles Newark's growth from village to bustling city, with an emphasis on images from the turn of the 20th century, and it documents many physical, economic, cultural, and social changes as seen through the lens of the Newark Historical Society's extensive historical collections.

Beginning in the second half of the 18th century, residences and stores were built along Main Street, which served as both the residential and economic center of the town. As industries and businesses grew, many were established on the outskirts of Newark, yet Main Street continued to maintain its role as the heart of the town. Chapter one traces that history and documents the many businesses that once lined Main Street. As the town's population increased, there was high demand for development adjacent to Main Street. Streets such as Academy, Chapel, Choate, and Haines were established perpendicular to Main Street, while Delaware and Cleveland Avenues ran parallel. As early as 1786, a free African American community began to grow along New London Avenue and expanded continuously after the Civil War. By the turn of the 19th century, Main Street had shifted from being largely residential to housing primarily businesses. As seen in the images included in this volume, the look and feel of Main Street have changed throughout the decades, as mixed-use structures have been built with an eye toward retail establishments on the lower level and apartments or condominiums on the upper floors.

A significant factor in Newark's growth was the establishment of Newark Academy. Originally founded by Rev. Francis Alison in New London, Pennsylvania, the school that would become the Newark Academy was chartered by Thomas and Richard Penn in 1769. Despite having to close for three years due to the American Revolution, by 1818, the student population at the academy had grown, and the board of trustees began to raise funds for the establishment of a college. Newark College was opened in 1834. In 1843, its name was changed to Delaware College, and in 1921, it expanded to become the University of Delaware. The Delaware Women's College opened in 1914, and in 1945, it merged with the university to become a coeducational institution. As student enrollment increased, so did the university's physical presence in Newark. Chapter two documents the history and expansion of the university and its impact on Newark's landscape and community. As the campus has expanded, the university has repurposed many of Newark's historic homes and businesses. The University of Delaware has indelibly changed the character of Newark and has played a significant part in its economic security.

Chapter three includes many of the residents and businesses that played a role in Newark's growth. Many of Newark's prominent citizens and leading industrialists served the city in some

civic capacity, whether on the town council or on the board of one of its organizations. For example, J. Pilling Wright began the American Hard Fibre Company in 1898 and the Continental Diamond Fibre Company in 1905, and he also served on the Board of Trustees of the University of Delaware. Many of these residents, such as local dentist Eri Haines and the Choate family, are now remembered through the streets named after them. Businesses such as the Deer Park and Klondike Kate's have become iconic Newark landmarks, while buildings that once housed thriving businesses have been demolished or renovated and consequently are unrecognizable today.

The emergence of industries along the banks of White Clay Creek began with the establishment of Thomas Meeteer's paper mill in 1789 and continued with the construction of the Dean Woolen Mill in 1845. The variety of industries that were established in Newark and the transportation networks that contributed to their success are documented in chapter four. Newark benefitted from the development of the Curtis Paper Mill, the National Vulcanized Fibre Company, Chrysler, and the Continental Diamond Fibre Company, among others. These industries flourished with the arrival of railroad networks, including the Philadelphia, Wilmington & Baltimore Railroad. The company laid tracks a mile south of Main Street in 1836 and provided both passenger and freight service. This connectivity encouraged growth southward as travelers and students began arriving via rail. By 1872, the Pomeroy & Newark Railroad passed north to south through the center of town. From 1883 to 1884, the Baltimore & Ohio Railroad laid tracks bisecting Main Street at the Deer Park Hotel, making Delaware Avenue and the north side of town more easily accessible for passenger and freight service and leading to the opening of Cleveland Avenue in 1893.

In addition to industry, Newark residents established schools, churches, banks, post offices, newspapers, a library, and a multitude of local civic organizations. Freemasons organized in town as early as 1789, and other fraternal organizations soon followed. The first Newark newspaper, the *Saturday Visitor*, was established in February 1876; in 1910, Everett Johnson founded the *Newark Post*, and that newspaper continues to serve the city. In 1888, the Aetna Hose, Hook and Ladder Company was founded in response to the devastating fire at the Dean Woolen Mills in 1886. These organizations helped to create a tight-knit community of residents, and chapter five documents these important institutions.

This sense of community led to the founding of the Newark Historical Society in 1981 to preserve and document Newark's growth. Unless otherwise noted, the images included here come exclusively from the society's rich collection of postcards, photographs, objects, manuscripts, and more, many of which have never been published. These images document changes to the city and its industries over several centuries and also capture the ongoing sense of community and pride among its residents. Regardless of the changes brought by time, industry, and development, Newark continues to grow and prosper.

One

MAIN STREET
AND VICINITY

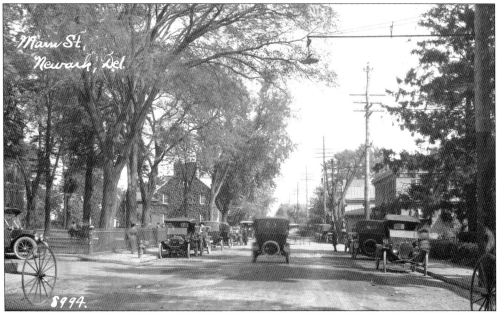

This photograph, taken by Ed Herbener in the early 1900s near the intersection of North College Avenue, looks east down Main Street. Recitation Hall, the third building constructed for the campus of Newark College, is visible on the left. The image depicts activity on Main Street when cars had gained some popularity but horse-drawn carriages still remained.

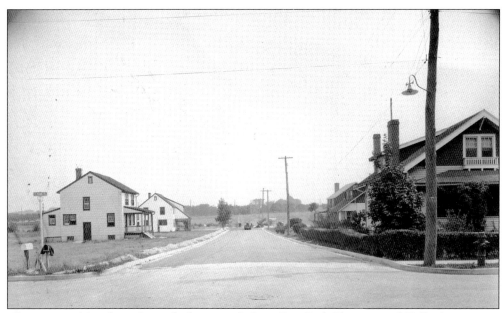

This image of Academy Street looking south from East Park Place toward Kells Avenue was taken in 1930. The installation of sidewalks along Academy Street was part of the Governor's Emergency Relief Commission as part of a statewide plan to provide work for citizens during the Great Depression. The project was planned to give work to all of Newark's unemployed who had applied to the mayor's committee for economic assistance. The image below of the intersection of Academy Street and Kells Avenue was likely taken in 1936 and shows the street fully paved with sidewalks installed. Academy Street now runs through the heart of the University of Delaware campus.

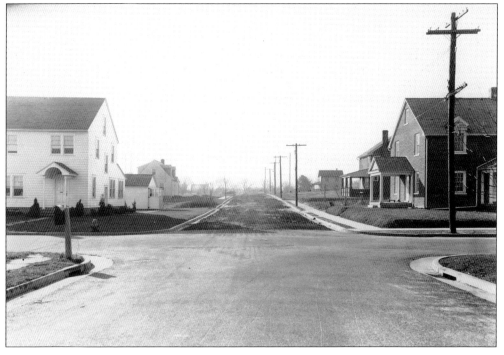

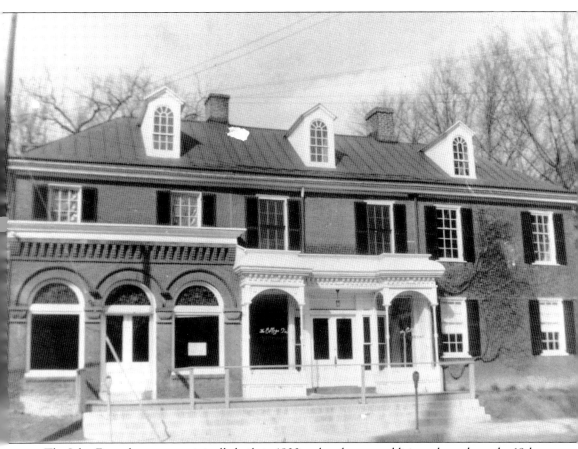

The John Evans house was originally built in 1800 and underwent additions throughout the 19th century. From 1870 until 1888, two Delaware College presidents made their homes here. Following that, the building was converted for commercial use, and in November 1921, the Blue Hen Tea Room and Gift Shop opened. Originally managed by Miss Jones, the sister of Edgar Jones, rector of the Episcopal Church, the business later passed to the ownership of Mrs. Herbert Reynolds, who hosted parties and banquets there throughout the 1920s. In the mid-1930s, the restaurant was known as the College Inn until it was purchased by the University of Delaware in 1947, which reinstated the Blue Hen Tea Room name. In the mid-1960s, the Blue Hen Tea Room relocated to 64 East Cleveland Avenue. The original location is now known as Raub Hall and houses the University of Delaware's Department of Hospitality and Sport Business Management.

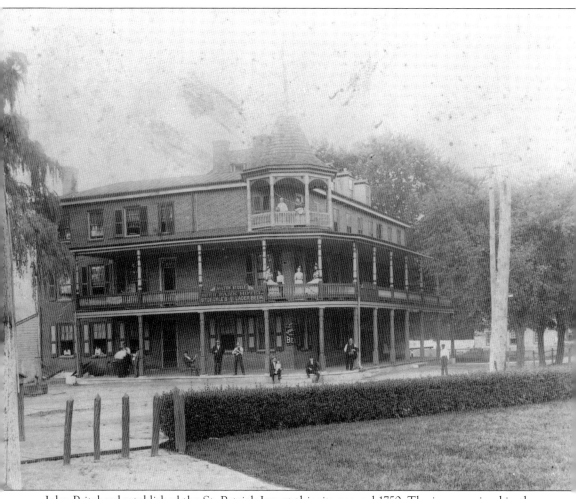

John Pritchard established the St. Patrick Inn at this site around 1750. The inn remained in the Pritchard family for almost 100 years until the Deer Park was constructed on the site in 1851. Since that time, the Deer Park has operated as a tavern, hotel, and boardinghouse. Between 1883 and 1884, the Baltimore & Ohio (B&O) Railroad line was constructed through Newark next to the Deer Park, increasing its popularity among travelers. This photograph of the Deer Park was taken around 1905 when it was owned and operated by Milton Steele. Steele was born in 1842 and purchased the Deer Park from John Lewis around 1894. Steele tried to sell the Deer Park for $27,500 in April 1899 but continued to operate the hotel after the deal fell through. Through the mid-to-late 1800s, the Deer Park Seminary and the Newark Academy, with Hannah Chamberlain as principal, also held classes in the hotel. The Deer Park continues to operate as a tavern and restaurant.

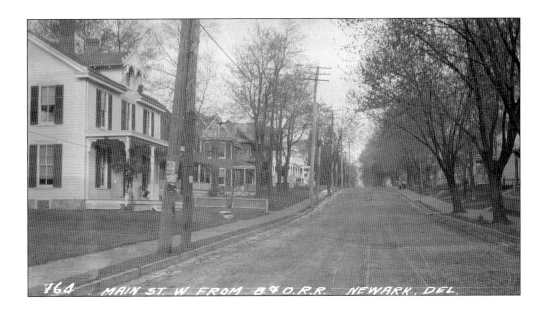

Both of these images were taken by Ed Herbener in the early 1900s. The image above shows West Main Street looking west from the B&O Railroad tracks, which were laid between 1883 and 1884. Once known as "Quality Hill," many of Newark's most prominent citizens maintained homes on this section of West Main Street, including members of the Cooch, Curtis, Pilling, and Wright families. The image below depicts a wider view of the intersection with West Main Street and New London Avenue. The Deer Park is visible on the right. (Courtesy of Mary Torbey.)

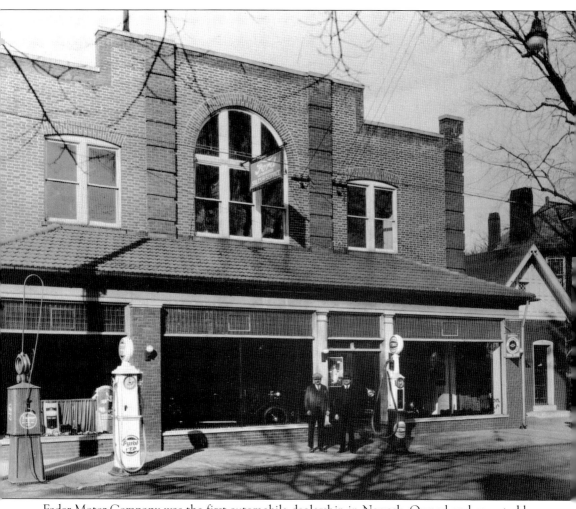

Fader Motor Company was the first automobile dealership in Newark. Owned and operated by Andrew Franklin Fader until his death in 1963, the business was located at 42 West Main Street near the Deer Park and is now the site of the University of Delaware's Willard Hall. Fader was born in 1886 and received a degree in electrical engineering from Delaware College in 1906. After opening a garage in 1911, Fader Motor Company became a Ford Motor Company franchise in 1913. As cars gained in popularity, Fader's sales increased. Fader lived at 287 West Main Street. Active in local organizations, he served as president of the Newark Lions Club, was one of the founders of the Newark Country Club, and was a member of the State Highway Commission. Fader is buried at Head of Christiana Cemetery.

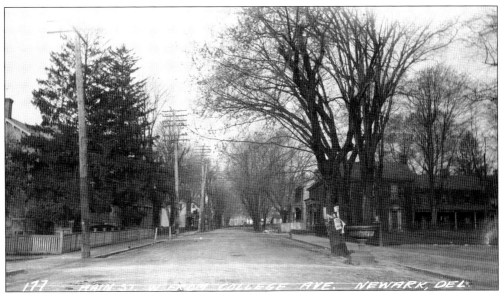

This image of Main Street looking west was taken from Old College, as evidenced by the iconic horse trough that sat in front of that building. The trough is now on display outside the Newark Senior Center. The home on the right was constructed around 1800 and was purchased by John Evans in 1804; he later operated a cabinet shop and general store here. His son George Gillespie Evans owned the home on the opposite side of the street.

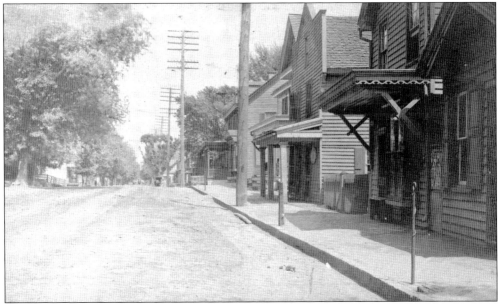

This undated image of Main Street features Charles Steele's butcher shop on the right. Steele's shop was first located across from Old College, and then in 1918 the whole building was picked up and moved across from the Deer Park. Steele followed in the footsteps of his father, William Henry Steele, who also operated a butcher shop in Newark beginning in the 1880s.

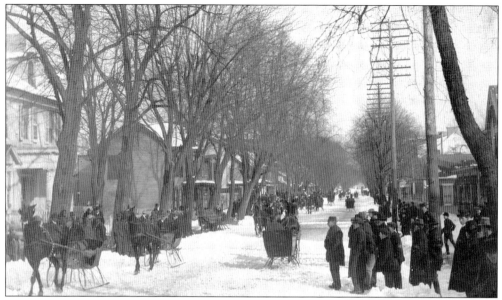

Before the large-scale adoption of automobiles, a popular pastime in Newark at the turn of the 20th century was sleigh riding down a snow-covered Main Street. In fact, sleigh racing was a regular sport, with a starting line at the B&O tracks near the Deer Park and a finish line at the railroad crossing east of Chapel Street. The sport remained popular throughout the 1920s. (Courtesy of Mary Torbey.)

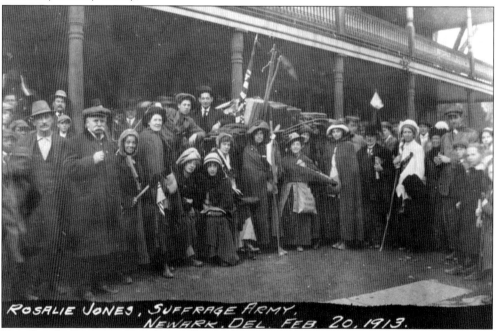

Gen. Rosalie Jones was an ardent suffragist from New York whose march to Washington, DC, in February 1913 passed through Newark. She is pictured here (to the left of the woman in the center holding the triangular pennant) with her Suffragist Army of the Hudson in front of the Deer Park Hotel. Students from Delaware College and other residents welcomed the group to Newark on February 20, 1913.

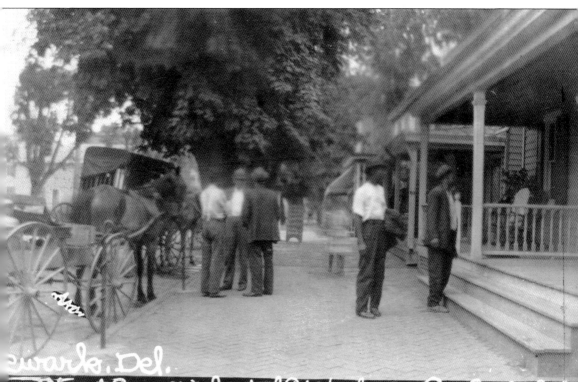

ewark, Del.

Street Scene in front of Ed Herbener Post Card Shop

Ed Herbener was a traveling photographer and postcard salesman based in Newark and is recognized as one of the pioneers of the postcard business. Herbener produced many real photo postcards of scenes around Newark at the turn of the 20th century. An 1896 advertisement lists him as manager of the United View Company, and the 1910 census noted his occupation as a publisher of souvenir postcards. Herbener not only photographed the Newark area but also produced images and postcards of areas along the East Coast from New York to North Carolina. Born in Pennsylvania in 1867, Herbener was raised in Newark, where his father operated a tailor shop. Herbener maintained a postcard and music shop on Main Street from the early 1910s until 1920, when he relocated his business to Washington, DC. Herbener eventually returned to Newark and died in 1938. (Courtesy of Mary Torbey.)

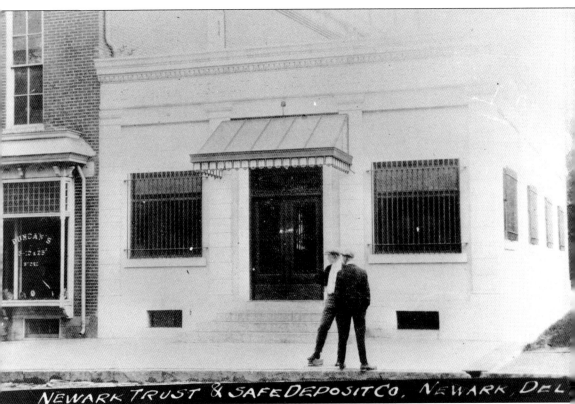

NEWARK TRUST & SAFE DEPOSIT CO, NEWARK, DEL

As the town's population increased, the establishment of local banking services soon followed. In the early 1900s, two banks, the Farmers' Trust and the Newark Trust and Safe Deposit Company, were founded. The Newark Trust and Safe Deposit Company was originally located on Academy Street in the rear of Caskey Hall. It later moved to the location shown here, with a storefront on Main Street and adjoining Caskey Hall to the right. In addition to banking, the Newark Trust and Safe Deposit Company maintained a real estate department that assisted with the development of local properties, including homes along Kells Avenue near South College Avenue. Members of the board of directors included prominent businessmen, lawyers, and farmers such as Samuel J. Wright, Henry Kollock, and Charles Evans. In 1944, the bank established an agricultural loan department to assist local farmers with equipment and crop loans as well as repairs. Later, the bank was purchased by the Farmers' Bank of the State of Delaware.

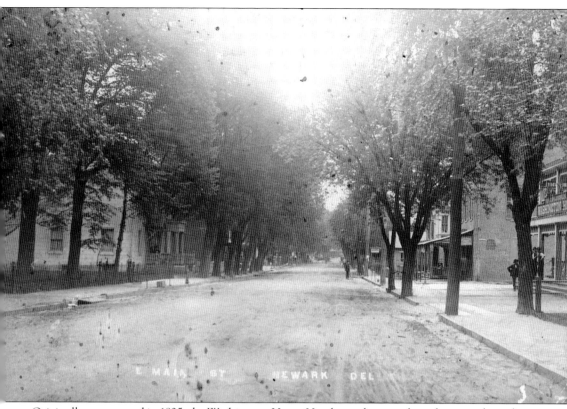

Originally constructed in 1825, the Washington House Hotel, seen here on the right, went through a series of owners and additions but has remained a Newark landmark. In 1911, Newark native Vic Willis purchased the 15-room hotel from George Johnson. Willis retired from professional baseball after 13 seasons and resided in the hotel with his wife and daughter. The hotel was remodeled in 1926, including the addition of five rooms and a new front. Willis operated a restaurant for guests. Active in civic organizations, Willis was a member of the Order of Elks and was active in the Democratic League of Wilmington. Willis continued operating the hotel through the 1940s and died in Newark in 1947. He was inducted into the Baseball Hall of Fame in 1995. (Courtesy of Mary Torbey.)

This view of New London Road was taken just north of the B&O Railroad tracks. This area of Newark originated as a free Black community beginning in the late 18th century, and its population continued to grow after the Civil War. As African Americans migrated north from southern states, many settled in Newark, though local ordinances prohibited them from renting or owning property outside of designated locations. Although those laws were outlawed in the late 1910s, segregated housing in Newark continued until the Federal Fair Housing Act in 1968. The "School Hill" community formed in the New London Road area, named for the New London Avenue School that served as an important gathering place for residents. The neighborhood housed several churches and businesses, including a convenience store and hair salons. In recent decades, many of the homes have been demolished to make way for student rental properties, forever changing Newark's African American community.

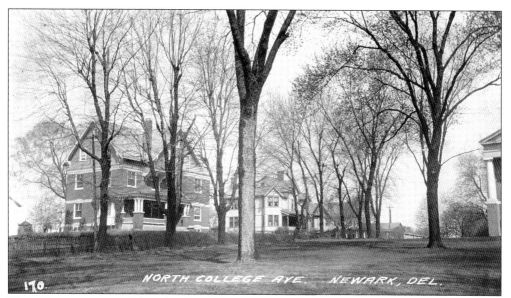

This image captures North College Avenue between Main Street and Cleveland Avenue when it was lined with family homes. Old College is visible on the right. McDowell Hall was constructed on this site and dedicated in 1972 to house the College of Nursing. It houses the School of Nursing and classrooms today.

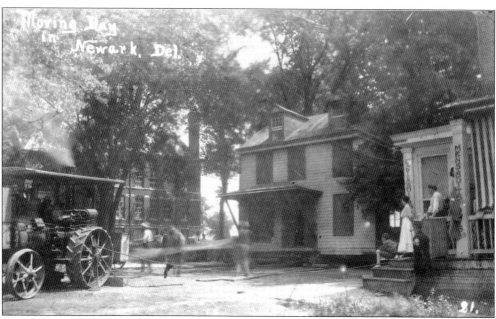

Located northeast of the intersection of South College and Main Street, Sally Roach's home was next to what was then Frazer's Drug Store. Roach operated an ice cream parlor frequented by Delaware College students in the left half of her building, and she lived in the right half. In 1910, she moved the shop section from its location on Main Street to East Delaware Avenue, where the University of Delaware's Wolf Hall is currently located. She moved the dwelling section to 55 Choate Street, where it still stands today with modifications. (Courtesy of Mary Torbey.)

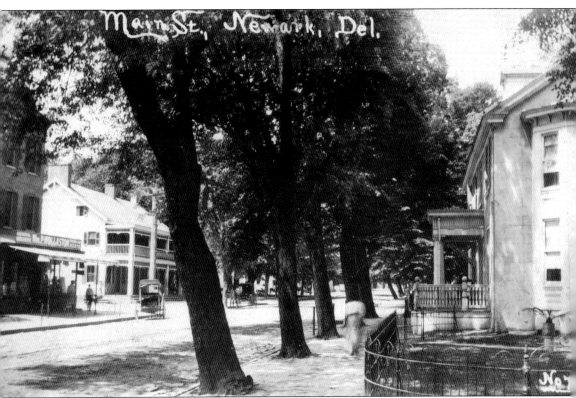

Dr. Henry Kollock, originally from Millsboro, Delaware, began practicing medicine in Newark around 1874 after attending Newark Academy and Jefferson Medical College. In this view of Main Street, dating from the turn of the 20th century, Dr. Kollock's office is the white building on the right. Wollaston's General Store is across the street. Active in civic affairs, Kollock served on the Board of Directors for the Newark Trust and Safe Deposit Company and as the physician for both the B&O and PW&B Railroads. Kollock served on the Board of Trustees of Delaware College from 1882 until his death in 1928. Professionally, Kollock served as president of both the Delaware State Medical Society and the New Castle County Medical Society. In addition, he served many years on the town council and the local board of health. (Courtesy of Mary Torbey.)

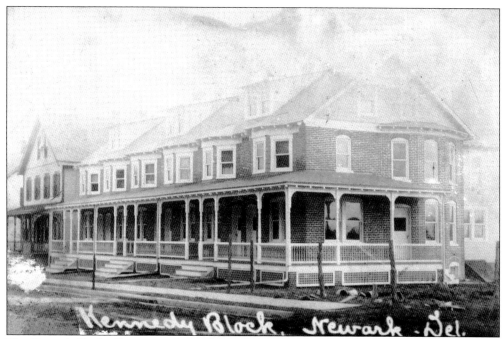

The Kennedy block of homes was located on Delaware Avenue between South College Avenue and Academy Street. The area where these homes were located is now the parking lot behind the Odd Fellows building and the Newark United Methodist Church. This image was taken around 1913.

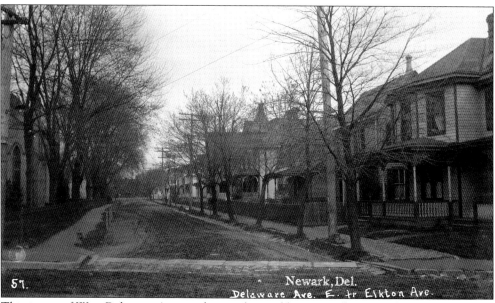

This image of West Delaware Avenue depicts the road between Elkton Road (now South Main Street) and South College Avenue. Construction of this portion of Delaware Avenue was approved by the New Castle County Levy Court in 1859 to provide a link between Elkton and Depot Roads. Construction on St. Thomas Episcopal Church, visible on the left, was begun in 1843. The building was consecrated in 1845.

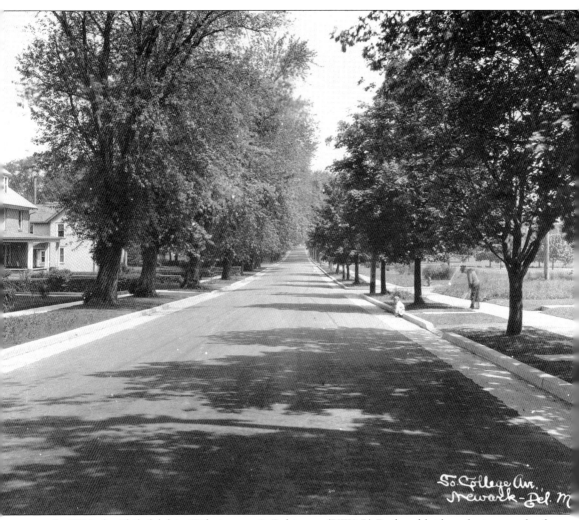

In 1836, the Philadelphia, Wilmington & Baltimore (PW&B) Railroad laid tracks just south of Newark, and its arrival marked a change in the town's growth. Originally called Depot Road because it led to the train depot, South College Avenue was laid in 1841. Although its name officially changed on many town maps in the early 1900s, the *Newark Post* continued to refer to it as Depot Road through the mid-1920s. With the rise of automobiles, South College Avenue became popular for speeding, a problem that endangered many pedestrians. This portion of South College Avenue was, and often still is, the first glimpse of Newark that many visitors see when they arrive via train, especially those visiting the University of Delaware, as this street leads directly to Old College. Taken on May 23, 1929, this image depicts South College Avenue fully paved with curbs and sidewalks installed.

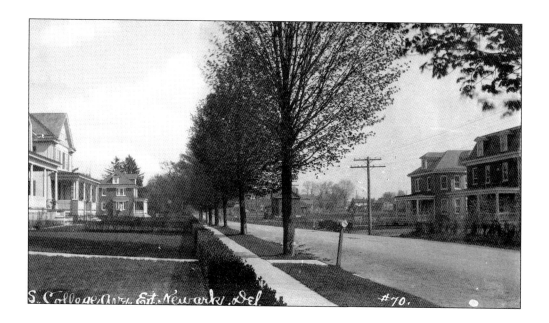

These two photographs of South College Avenue were taken by Ed Herbener around the same time. The image above appears to be taken looking north along South College toward Kells Avenue. The photograph below was taken sometime after 1914, as evidenced by the Women's College visible on the right-hand side. Today, much of South College Avenue remains tree-lined, but many of the family homes on the street have been purchased by the University of Delaware and are offered as rental properties for university faculty and staff.

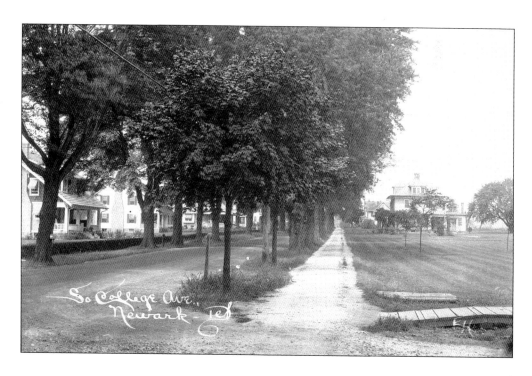

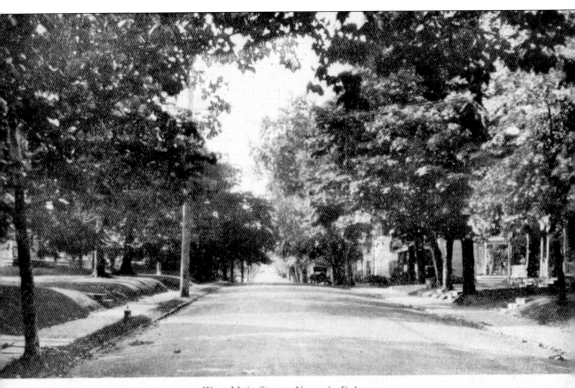

West Main Street, Newark, Delaware

Separated from downtown Newark by the B&O Railroad tracks, most of the homes located here were built in the late 19th century by some of Newark's wealthiest citizens. Large portions of Quality Hill had once been part of Rathmell Wilson's "Oaklands" property. Wilson was a prominent Newark landholder who owned property along New London Road and Main Street. He served on the Board of Trustees for Delaware College from 1844 to 1888, in addition to being acting president of the college from 1859 until 1870. Wilson invested in and sold land to the Baltimore & Philadelphia Railroad to establish the B&O line through Newark. Wilson was also active in establishing curbs and sewer lines throughout the town. Many of these homes have now become student rentals or have been divided into apartments.

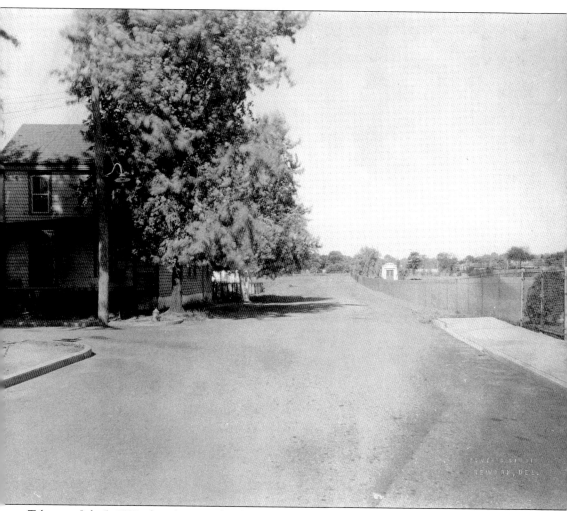

Taken on July 5, 1932, this photograph of New Street looking west from Choate Street toward Center Street features Newark Cemetery on the right. Town engineer Merle Sigmund oversaw improvements to many of Newark's streets throughout the 1930s, including those on New Street, recently paved at the time of this photograph. Improvements involved paving, storm sewer installation, and extending water and power lines. Today, many of the homes on this street have become student rentals, and several small apartment complexes have been constructed. Newark Cemetery stretches from North Chapel Street to Center Street and is bordered by the B&O Railroad tracks to the north. Originally administered by the Newark United Methodist Church, the earliest graves date from 1812. Among those interred in the cemetery are various members of the prominent Choate, Dean, Pilling, and Wright families.

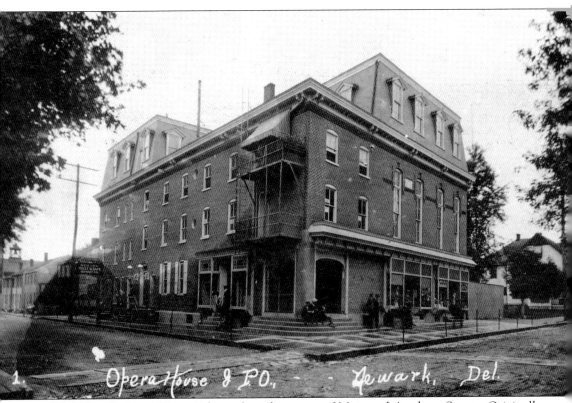

The Newark Opera House is located on the corner of Main and Academy Streets. Originally constructed by David Caskey in 1885 and known as Caskey Hall, in 1902, the building was purchased by Samuel Wright. Wright remodeled the hall and added another floor. Renamed the Newark Opera House, theater productions, concerts, and motion picture screenings were held on the second floor, while the ground floor was occupied by a series of retail businesses. Among the businesses located here were J. Rankin Armstrong's "Double Cash Store," in addition to a barbershop, soda shop, and drugstore. While under new ownership in the 1930s, the top floors of the building were converted to apartments, but the existing retail space was maintained on the ground floor. (Courtesy of Mary Torbey)

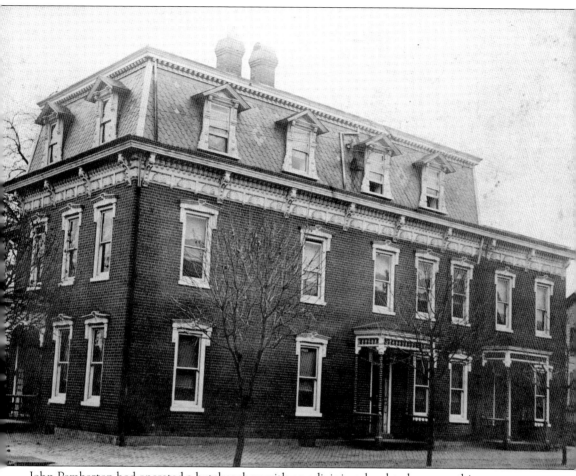

John Pemberton had operated a butcher shop with an adjoining slaughterhouse on this property on the corner of Academy and Main Streets for many years, much to the dismay of his neighbors. David Caskey had built the Green Mansion on the opposite side of Main Street in 1882, and he purchased the Pemberton property in 1885. Caskey was born in Pennsylvania in 1828 and was a retired farmer at the time that he constructed the Green Mansion and Caskey Hall. Caskey moved to Glenolden, Pennsylvania, by 1900 and sold the hall to Samuel Wright in 1902. Caskey died at his Pennsylvania home in January 1918. Wright renamed the building the Newark Opera House, and then in 1926, he sold the building to John K. Johnston and J. Irvin Dayett. This view is of the Academy Street side.

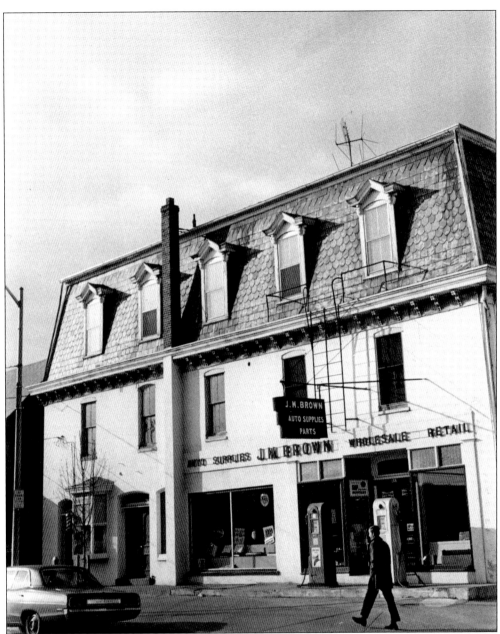

Beginning in 1739, Ebenezer Howell operated the Three Hearts Tavern at this location. The location was home to an inn and tavern until 1880, when the three-story Exchange Building was erected on the site. Initially, the building was used as a cooperative store and a grange hall. Over the past century, the building has been used for a variety of purposes, including a post office, movie theater, meeting rooms for fraternal organizations, meat market and general store, tailor shop, barbershop, and pool hall. In the early 1900s, the building was used as a courthouse with a jail cell located in the basement. This photograph was taken sometime in the 1960s or 1970s when the building was home to J.M. Brown's Auto Supplies, which operated on the site beginning in 1929. In 1977, the building was sold and, in 1979, was converted into a tavern and restaurant; it is currently home to Klondike Kate's.

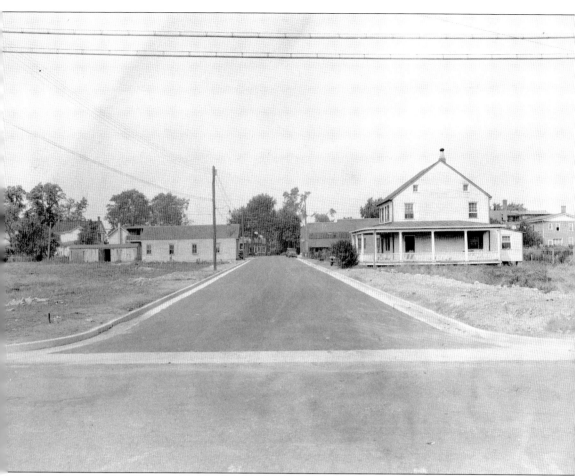

This photograph of Haines Street was taken in 1934 after it had been paved. Looking north from Delaware Avenue, Main Street can be seen in the background. The frame house on the left has been set back. Haines Street was named for local dentist Eri Haines, who served the community for approximately 50 years. Haines was born in Rising Sun, Maryland, in September 1823, but he began practicing dentistry in Newark after receiving his diploma in dental surgery from the Philadelphia School of Dentistry in 1854. Haines's office was located on Main Street, approximately where Haines Street intersects it today. In addition to dental services, Haines also produced artificial teeth. By 1884, Haines's son Harry had joined his father's practice, in addition to operating a livery stable. Eri Haines died in January 1907 and is buried in Newark Cemetery.

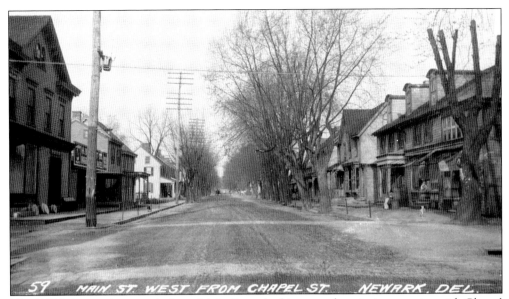

This Ed Herbener photograph shows Main Street looking west from its intersection with Chapel Street. This photograph was taken at a time when family homes outnumbered businesses on Main Street. One notable business was H.B. Wright and Co., a hardware store that was a prominent dealer in wagons and carriages. Horse-drawn carts and carriages are visible further west on Main Street. Wright operated his business for approximately 50 years.

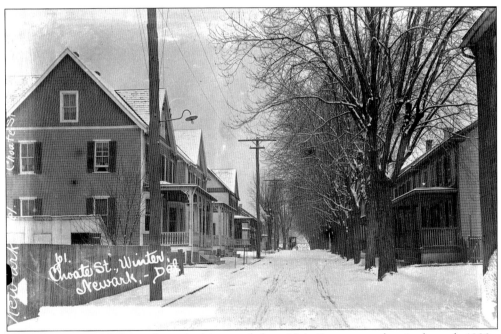

This winter scene of Choate Street looking north from Main Street was taken in the early 1900s. The B&O Railroad tracks are visible in the background. The street was laid around 1879 and named for members of the Choate family. Brothers Daniel, David, and Stephen were prominent Newark residents and businessmen. Originally consisting of single- and two-family dwellings, today, the homes along Choate Street are primarily student rentals.

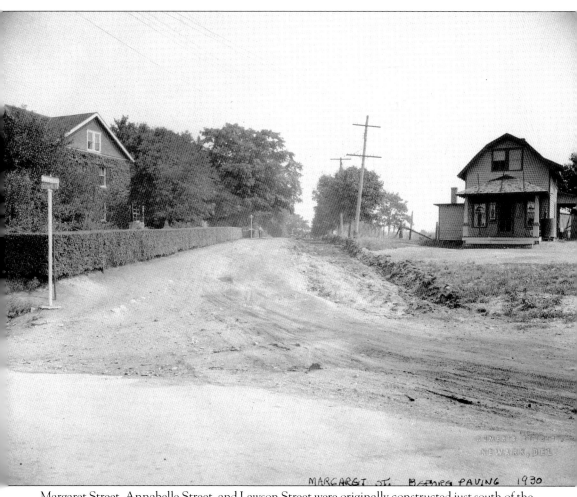

MARGARET ST. BEFORE PAVING 1930

Margaret Street, Annabelle Street, and Lawson Street were originally constructed just south of the Dean Woolen Mill along White Clay Creek to provide housing for employees and their families. Margaret Street was named for William Dean's wife, Annabelle Street for his daughter, and Lawson Street for his son-in-law. The neighborhood formed by these three streets is sometimes referred to as "Deandale." Following the destruction of the woolen mill in an 1886 fire, the American Vulcanized Fibre Plant was founded on the site, and many employees of the new company lived in these homes. Taken in 1930 before paving, this image depicts the intersection of Margaret and North Chapel Streets. In October 1929, J.K. Johnson, the vice president of the National Vulcanized Fibre Company, appealed to the mayor and town council to improve Margaret Street, which flooded with each rain. Subsequently, curbs and gutters were installed. Today, these homes are primarily occupied by student renters.

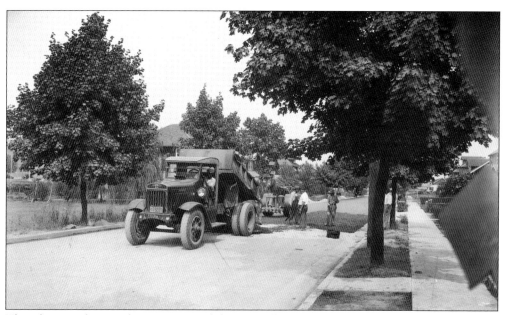

This photograph was taken in 1930 and depicts Kells Avenue, between South College Avenue and Academy Street, as it was being paved. In 1929, the Council of Newark approved a street improvement program that included paving as well as the creation of gutters and curbs on many Newark streets.

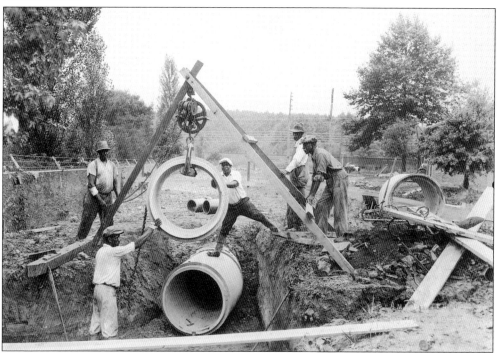

Amstel Avenue connects South College Avenue and Elkton Road, now South Main Street. This image of a storm sewer being installed on Amstel Avenue was taken in July 1932. The sewer was laid to replace an open ditch from Elkton Road. The B&O Railroad tracks can be seen in the background.

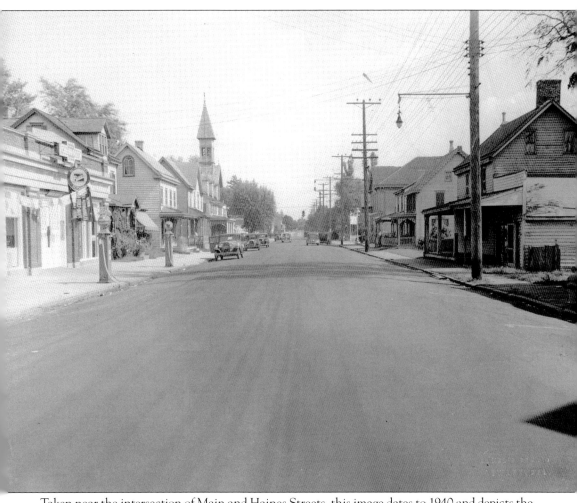

Taken near the intersection of Main and Haines Streets, this image dates to 1940 and depicts the eastern portion of Main Street. A Chevrolet and Buick car dealer can be seen on the left before most dealerships relocated to Cleveland Avenue. The steeple of St. John the Baptist Roman Catholic Church can be seen in the left background. Prior to 1955, traffic on Main Street was two-way, but in 1956, Main Street was reconfigured to allow only one-way traffic, except for a few blocks on the eastern end of the street. Those blocks permitted two-way traffic into the 1970s. In 1955, Delaware Avenue also was extended to the new Newark High School. An increase in automobiles eventually led to a need to pave Main Street. The eastern end of the street developed at a slower rate, as evidenced by census records and maps. This section of Main Street remained largely residential as Newark grew, as businesses first developed around the Newark Academy building.

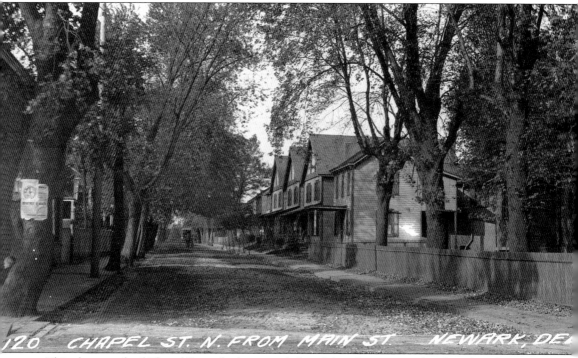

120 CHAPEL ST. N. FROM MAIN ST. NEWARK, DEL.

This photograph of Chapel Street looking north from Main Street was taken by Ed Herbener in the early 1900s. Chapel Street got its name from the Methodist chapel constructed in 1811 or 1812 at the eastern end of the lot that is now the Newark Cemetery. Before then, it was known as "Pilling's Row." This section of Chapel Street connected Main Street with industries such as Curtis Paper Mill, the Dean Woolen Mill, and later, the American Vulcanized Fibre Mill. As a result, most of the homes along North Chapel Street were occupied by employees and their families. According to the 1920 census, a large portion of the homes was rented by employees working in the fibre mill. Today, North Chapel is no longer lined with trees, and many of these homes have been converted into student rental properties in the past decades.

Two

University of Delaware

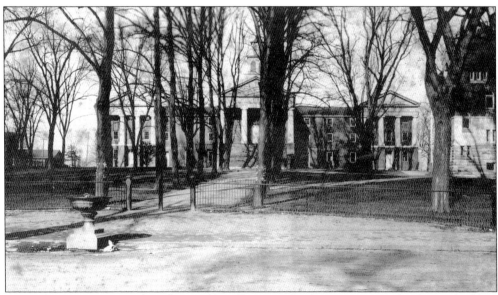

Opened in 1834 as Newark College, Old College was the first University of Delaware building and originally housed classrooms, a dormitory with a kitchen and dining room, and a library, in addition to other meeting rooms. The cupola was added to the building in 1852 but was removed in 1917. Today, Old College is home to the Departments of Art History and Art Conservation as well as classrooms, offices, and the Old College Gallery.

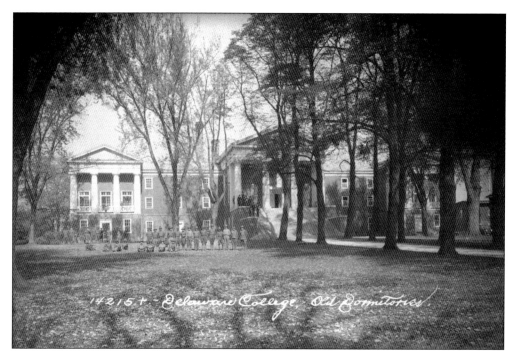

Designed by Winslow Lewis and constructed between 1832 and 1834, Old College was the only building of Delaware College until 1888, but by 1914 the campus had begun to expand. Old College was renovated in 1916 by architect Charles Klauder, who had been commissioned with his partner, Frank Miles Day. In 1918, a portion of the building was used to house World War I trainees. In 1890, the US Army established a military department at the college, and for the academic year of 1918–1919, the college was home to the No. 351 Student Army Training Corps. These two images by Ed Herbener were taken around this time.

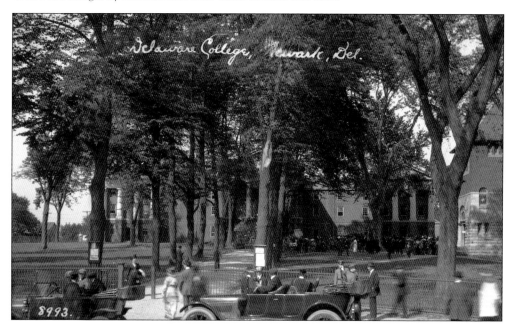

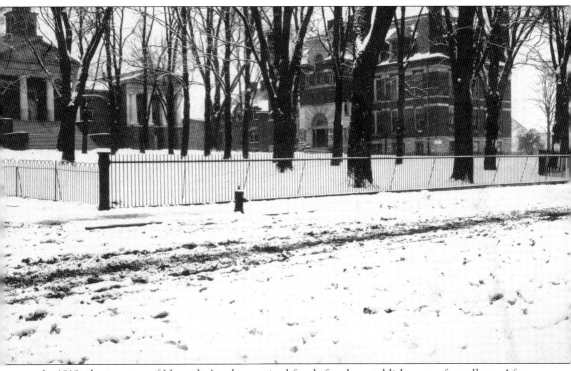

In 1818, the trustees of Newark Academy raised funds for the establishment of a college. After fundraising at state and local levels, Old College was constructed in the Greek Revival Style and opened in 1834. As the college grew, following a hiatus during the Civil War, more space was required. In 1888, the building now known as the Recitation Hall Annex was erected as the laboratory of the Agricultural Experiment Station of Delaware College. In the same year, Dr. Albert Raub, then principal of Newark Academy, became president of Delaware College. There were 29 students for the 1888–1889 school year; however, the number increased to 82 for the 1889–1890 school year, and the lack of space became dire. Under Raub's tenure, Recitation Hall was constructed and completed in 1892. Raub stepped down from the presidency in 1896 and was succeeded by George Harter. Harter remained president until 1914. Old College and Recitation Hall served as the campus center for decades to come.

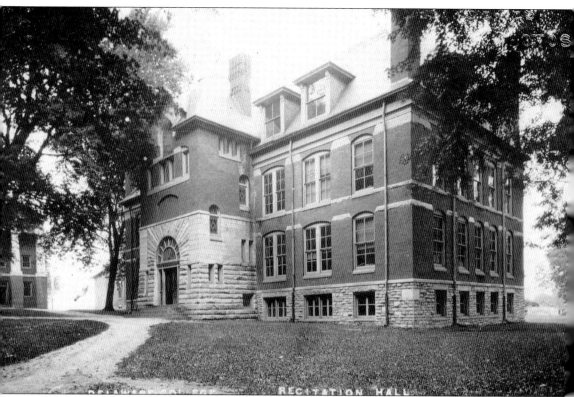

Recitation Hall was constructed in 1891 and 1892 and designed by Furness, Evans & Company, the same company that had constructed the B&O Railroad station in Newark in 1886. The building housed laboratories, an auditorium, and classrooms. By 1895, most classes of Delaware College met in Recitation Hall. It later housed administrative offices and lecture halls, as well as the college library from 1896 through 1909. After serving as the home to the University of Delaware's administrative offices through the 1920s, in 1942, the building was adapted to meet the needs of the physics department. The building was altered in 1963 when four chimneys were removed and again in 1968, when it became home to the Department of Art. Recently the building was renovated, and it currently houses classroom and studio space, as well as an art gallery. (Courtesy of Mary Torbey.)

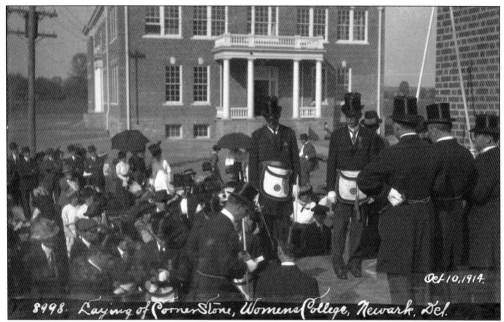

8998. *Laying of Corner Stone, Womens College, Newark, Del.* Oct. 10, 1914.

The Women's College was established in 1914. An attempt at higher education for women in Delaware had been made 30 years prior, in 1872, when the Board of Trustees at Delaware College passed a resolution allowing the admittance of women to classes. That fall, six women entered the freshman class. Women's enrollment declined beginning in the late 1870s, and coeducation was abolished in 1885. In 1913, Winifred Robinson became the first dean of the Women's College, and in 1914, construction was completed on two buildings that would constitute its campus. Science Hall, renamed Robinson Hall in 1940 to honor Winifred Robinson, was built as a classroom and laboratory building. Residence Hall, now Warner Hall, was constructed as a dormitory. It was renamed in 1940 to honor Emalea Pusey Warner, who played a significant role in the founding of the Women's College. (Below, courtesy of Mary Torbey.)

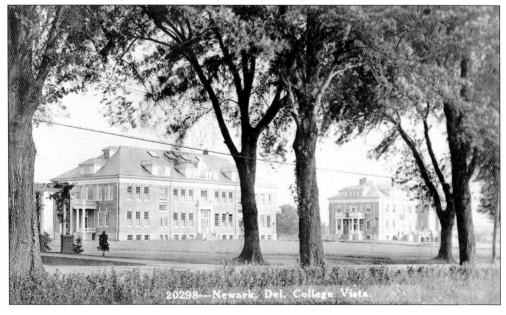

20298—Newark, Del. College Vista.

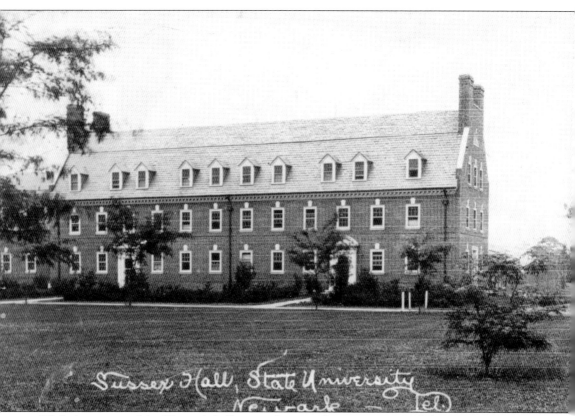

With the success of the Women's College, student enrollment necessitated the construction of a second dormitory. Sussex Hall was funded by the sale of bonds in 1917 and was completed in 1918. Located across The Green from Warner and Robinson Halls, construction of Sussex Hall was followed by Kent and New Castle Halls in 1926, as a need for additional space became evident. Both new buildings served as additional dormitories, and Kent Hall included a dining room for the college. This expansion freed up space in Warner Hall to be used as a women's faculty club room. Named for the three counties of Delaware, these three buildings were designed by architectural firm Day and Klauder and are still in use today. As space was needed, additional dormitories were constructed to the north and south of these three buildings. Of the three, Kent is the only one that remains a women-only dorm. (Courtesy of Mary Torbey.)

By 1914, student enrollment had increased, and the Delaware College Board of Trustees hired the architectural firm Day and Klauder to propose a plan for campus expansion, including the construction of the two buildings that became the Women's College. The expansion of campus also included a tree-lined mall, now known as The Green, that connected the men's and women's campuses and was bisected by Delaware Avenue. Two buildings, Wolf Hall and Harter Hall, were constructed in 1917 and are depicted above. Harter Hall, a 100-bed dormitory named for university president George Harter, is below. (Below, courtesy of Mary Torbey.)

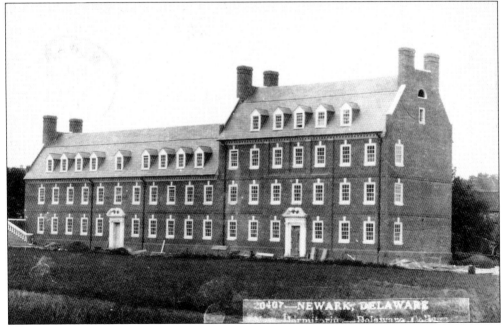

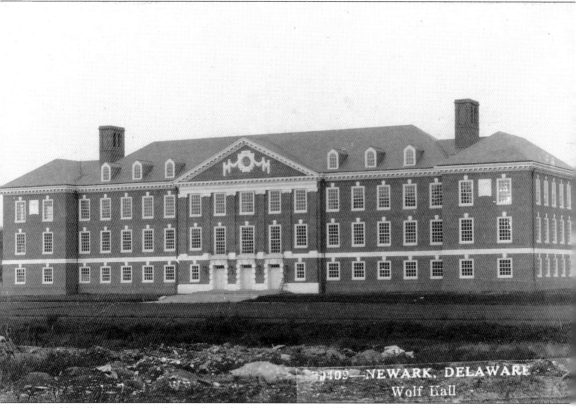

NEWARK, DELAWARE
Wolf Hall

Wolf Hall, a science and agriculture building named for Theodore Wolf, professor of chemistry, geology, mineralogy, and natural history, was completed in 1917 on the south side of Delaware Avenue, which began the southern expansion of the university campus. Wolf accepted a position as professor of chemistry in 1871. Wolf hired graduate students as his assistants and is credited with establishing the first internship program on campus. In addition to his teaching at the university, Wolf served as acting president for a brief period in 1901 and also served as a state chemist. Wolf died unexpectedly in 1909 at age 59, after teaching at the university for 38 years. The naming of Harter and Wolf Halls in 1917 represented the first time that university buildings were named for individuals. Wolf Hall is now home to the Departments of Psychological and Brain Sciences and Biological Sciences. (Courtesy of Mary Torbey.)

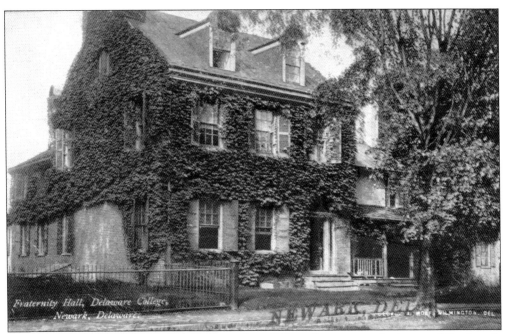

The building depicted here was constructed in 1809 and was once the home of Dr. Joseph Chamberlain. Chamberlain was born in Newark in 1788 and maintained a medical practice in Newark while also serving on the Board of Trustees for Newark, later Delaware College. Chamberlain died in 1849, and his heirs sold the home to John Watson Evans in 1866. Like Chamberlain, Evans served on the Board of Trustees of Delaware College. In 1903, the home was purchased by the university and served as a fraternity house from 1904 to 1909, and from 1909 until 1916, it housed the college library. In 1916, the building was named Purnell Hall for university president Dr. William Purnell before being renamed Alumni Hall in 1970. (Below, courtesy of Mary Torbey.)

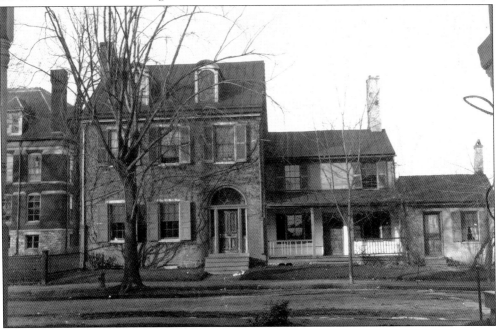

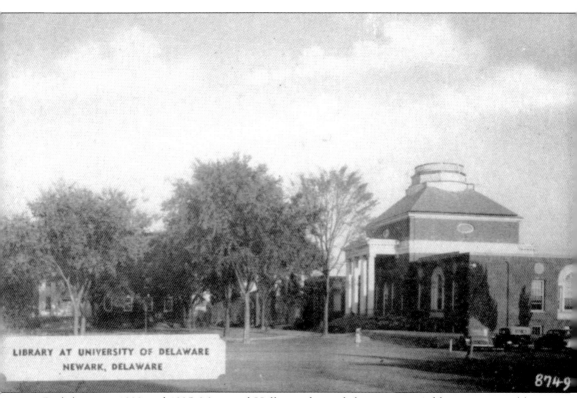

LIBRARY AT UNIVERSITY OF DELAWARE
NEWARK, DELAWARE

8749

Built between 1923 and 1925, Memorial Hall once housed the university's library. Proposed by Pres. Samuel Mitchell, the library was also intended to serve as a memorial to those Delaware residents who died during World War I and was funded largely by individual contributions. Located prominently on The Green, the building was designed by university architectural firm Day and Klauder and fit into their plans to create centralized campus buildings that unified Delaware College and the Women's College. Following the merger of the men's and women's colleges into the University of Delaware in 1921, Memorial Hall was the first building shared by both colleges and served as a focal point for the campus. The university's library collection was housed in Memorial Hall until 1963, when the construction of the much larger Hugh M. Morris Library was completed. Memorial Hall now houses the Department of English and classroom space. (Courtesy of Mary Torbey.)

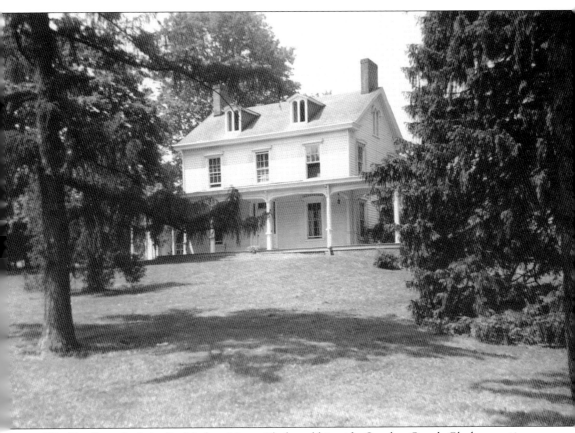

The Knoll was built by Dr. Nathan Hayes Clark and his wife, Carolyn Cooch Clark, sometime in the 1870s. Located on the corner of South College and Delaware Avenues, the Knoll, and three and a half surrounding acres, were purchased by Delaware College in 1917 to be used as the president's residence. Presidents Mitchell and Hullihen lived at the Knoll through 1944, after which the building served as a dormitory. In 1946, the building was used to house returning World War II veterans. Later that year, the last university president to live in the home, William Carlson, arrived on campus. Carlson was unhappy with the accommodations, and the university purchased a new presidential home at 102 Bent Lane. The Knoll was used as a women's dormitory until the home was demolished sometime in the 1960s to make way for the construction of Smith and Kirkbride Halls.

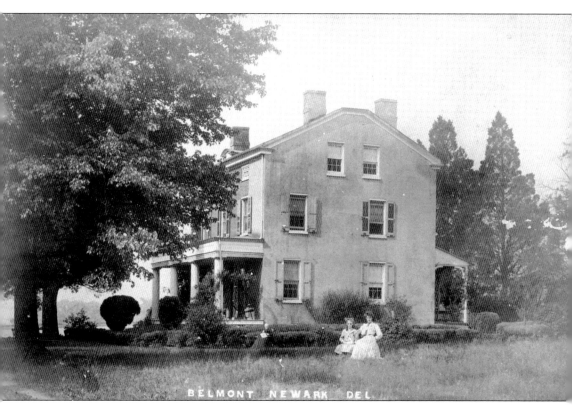

BELMONT NEWARK DEL

Belmont Hall was originally constructed between 1838 and 1844 as a home for Thomas Blandy. Blandy owned a local foundry near the Deer Park and approximately 40 acres of farmland surrounding the home on West Main Street. A devout Episcopalian, Blandy served as a lay delegate at St. Thomas Church in the 1840s and served on the Board of Trustees of Newark College. At the turn of the century, the home was sold to the Frazer family, and it was renovated in 1911. In 1950, the home was purchased by the University of Delaware as a home for the university president. The first president to live in Belmont Hall was John Perkins. The president's residence was moved to the Wright House on Kent Way when it was bequeathed to the university by Elizabeth Johnson Wright in 1961. Today, Belmont Hall is home to the Psychological Services Center and the English Language Institute. (Courtesy of Mary Torbey.)

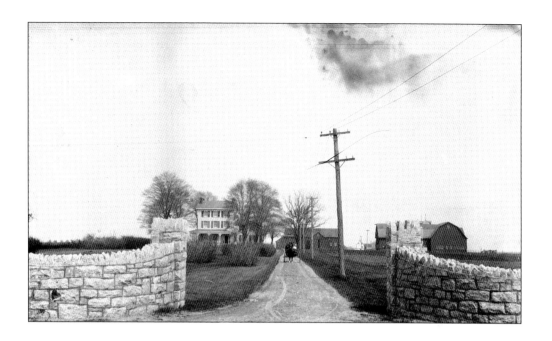

Built around 1860, this farmhouse originally belonged to W. H. Schultz. By 1893, the farm and home had been purchased by Edward R. Wilson. In 1907, the state of Delaware acquired Wilson's farm for use and management by the Board of Trustees of Delaware College. Delaware College had established a department of agriculture in the late 19th century, and the program quickly expanded. The farm served as an experimental farm for agriculture students and added to the college's existing research facilities in the Recitation Annex, constructed in 1887. The farmhouse was used as dormitory space for agricultural students in the 1960s and was renovated in 1999 for use as administrative office space.

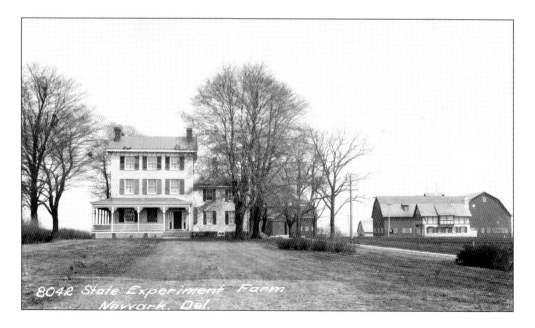

8042 State Experiment Farm
Newark, Del.

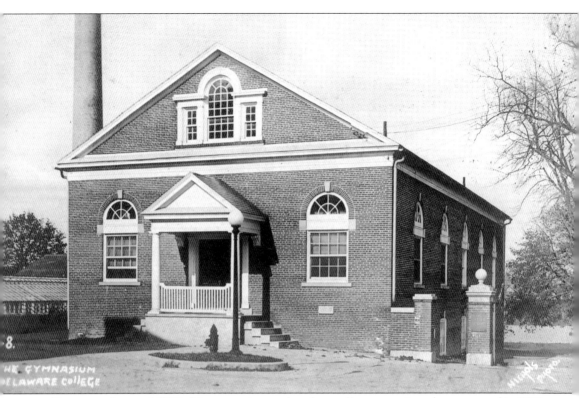

Constructed around 1905, this gymnasium replaced a smaller gymnasium that was razed in 1903 to allow for the expansion of the University of Delaware's Mechanical Hall. The state of Delaware allocated $12,000 for the project. Built northwest of Mechanical Hall, the new gymnasium had an indoor running track suspended from roof trusses. The main floor was occupied by a military drill hall and gym. Lockers and showers were located on the basement level. Opened in winter 1906, the building was used for basketball games, indoor drilling, dances, and special receptions. A small swimming pool was added to the lower level in 1913. In 1927, the gymnasium was expanded to include a larger pool and bleachers for sporting events. Opened in 1928, the remodeled gymnasium was named for alumnus Alexander Taylor, who had advocated for the addition. Taylor Hall is now the oldest surviving athletic facility on campus and houses studio and classroom space for the Department of Art and Design. (Courtesy of Mary Torbey.)

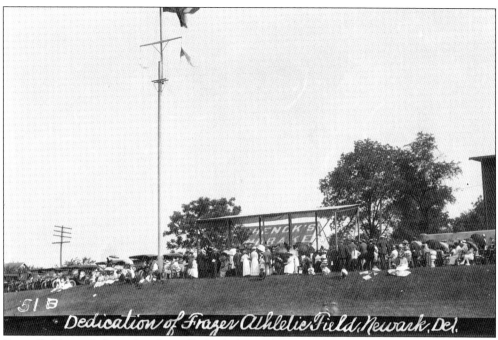

Dedication of Frazer Athletic Field, Newark, Del.

Frazer Field was dedicated on June 18, 1913. Located just northeast of Old College, the athletic field was constructed with funds donated by the parents of Joseph Heckart Frazer from their son's estate. Frazer had graduated from Delaware College in 1903 with a degree in civil engineering. Following graduation, he worked for the B&O Railroad. In 1904, he moved to Bolivia to create a railroad survey of the country, and later, he founded a company to build railroads there. Frazer died in Bolivia in 1911 after contracting influenza. Frazer Field was originally used for the university's baseball, track and field, football, and tennis teams. Today, the field is largely used for intramural and club sports.

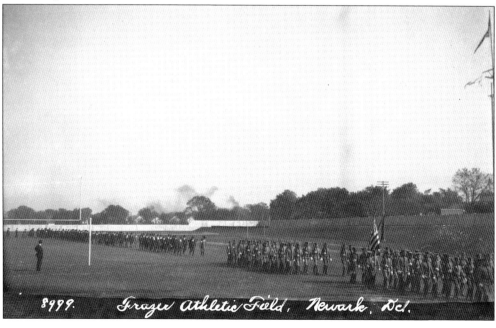

Frazer Athletic Field, Newark, Del.

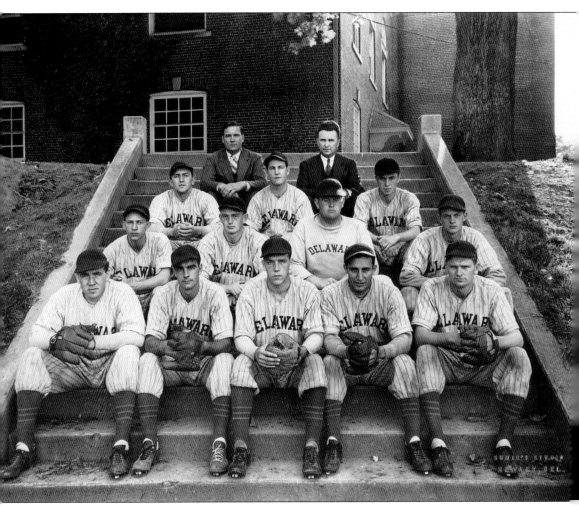

First played in the United States in 1862, baseball quickly became a popular pastime throughout the country. By the 1870s, baseball teams had been organized throughout the state of Delaware at the amateur level. The University of Delaware baseball program began in 1882. The first Blue Hen baseball player to join a major league baseball team was Vic Willis, who, although not enrolled at the school, was permitted to play for the team because of low student enrollment. Willis played professional baseball from 1898 until 1910 and was later inducted into the National Baseball Hall of Fame. From 1923 until 1958, the university's team played in the Middle Atlantic Conference with other institutions such as Princeton and New York Universities and Haverford, Gettysburg, and Swarthmore Colleges. This photograph, likely taken in the 1920s or 1930s, documents the university's team at that time.

Three

RESIDENTS
AND BUSINESSES

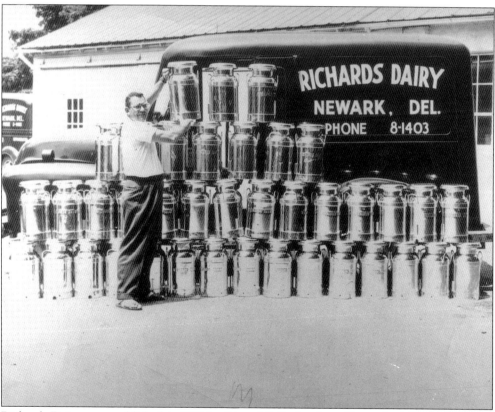

Richards Dairy was established in 1921 by Edward F. Richards and his wife, Lillian, when they purchased the business from German Dairy. Originally operated out of the family home at the southeast corner of Main and Haines Streets, the family and dairy soon moved to 22 Choate Street. Richards provided home delivery of milk and other dairy products.

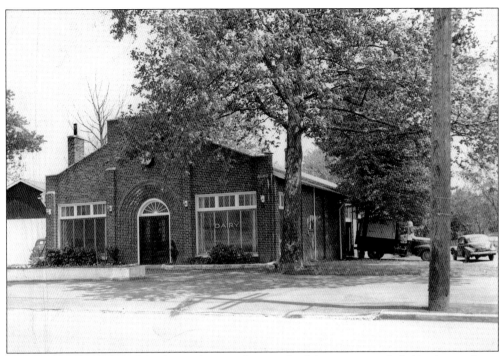

When Richards purchased the dairy, a horse and wagon for delivery were included in the purchase. In 1939, Richards acquired two other local dairies and outgrew the Choate Street location. The family home remained on Choate Street while the business moved to 57 Elkton Road, which now houses the Amstel Square apartments and retail space. Both Edward and his wife, Lillian, were actively involved in Newark civic organizations. Edward served in the Lions Club, and Lillian was a member of the New Century Club. This photograph of Edward and Lillian was taken after the business moved to Elkton Road.

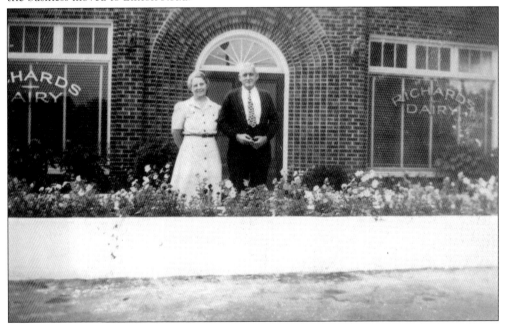

When Richards retired in 1953, he sold the dairy to his daughter Elizabeth and son-in-law Alexander. They continued operating the business until 1975. Throughout its operation, Richards Dairy delivered milk to residents in the surrounding area, first via horse and wagon and later in trucks. Pictured to the right is Edward and Lillian Richards' other daughter, Anne. Richards Dairy continued processing milk from local farms, with bottling facilities in the rear portion of the building and a storefront featuring ice cream and other dairy products. This image below of the bottling plant dates from the late 1950s.

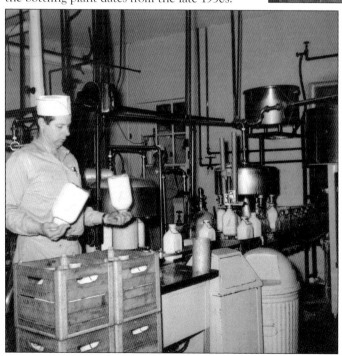

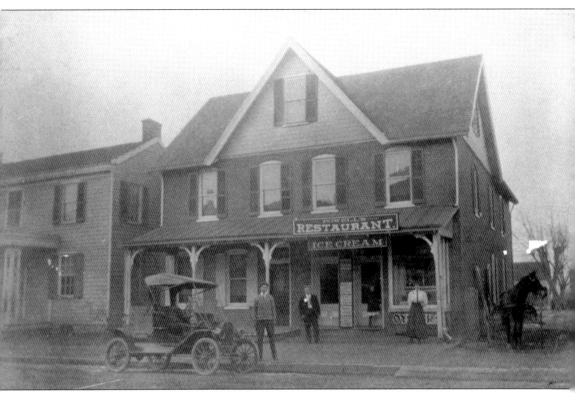

George Powell established a business at 36 East Main Street in 1887, selling ice cream and oysters. In 1897, he purchased 35 East Main Street and opened Powell's Restaurant. Powell was an active member of Newark's community, serving as a trustee of Newark Methodist Church and as a member of the Improved Order of Red Men. In 1909, Powell's son Walter took over the business and later moved the business to 43-45 East Main Street, pictured above. In 1917, Walter enlisted in the Army but returned to the business following World War I. While operating the restaurant at 43, the Powell family lived at 45 East Main Street. Powell expanded his real estate holdings and eventually owned at least six rental properties in Newark. In 1952, Powell sold the business to James Skinner but continued to live at 43 East Main until his death.

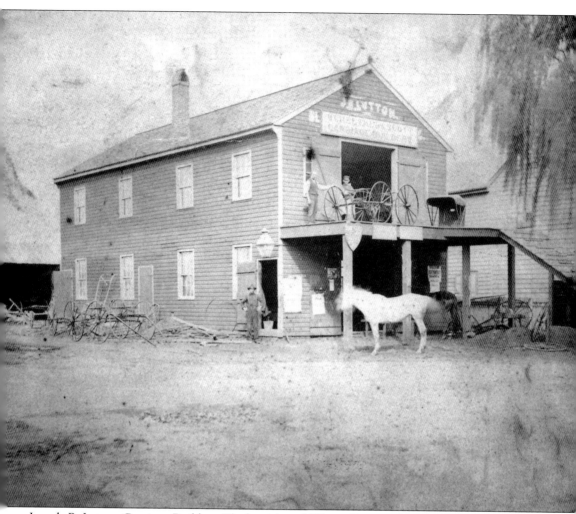

Joseph B. Lutton Carriage Builders, Blacksmith and Wagon Repair Shop was located on the northeast corner of Main and Choate Streets. The store operated from approximately 1880 to 1910, when Lutton retired. A prosperous businessman, Lutton was born in Elkton, Maryland, and moved to Newark after serving in the Seventh Delaware Infantry Regiment during the Civil War. Lutton was instrumental in founding the Aetna Hose, Hook and Ladder Company. He also served multiple terms as a town councilman, was a member of the Odd Fellows Lodge, and was active in veterans' groups. Lutton's children were also involved in civic affairs. His son Frank served as a street inspector in the early 1920s and was active in the Aetna Fire Company. Lutton died in his Main Street home on October 27, 1924, at age 80 and is buried in Newark Cemetery.

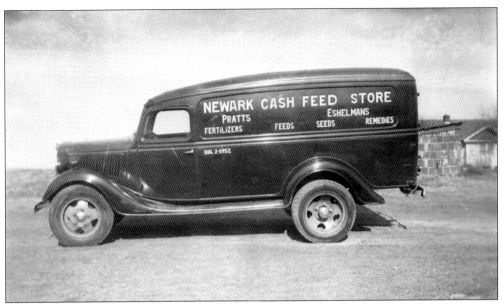

Even as Newark's population expanded, its farming roots remained, and agriculture remained a constant industry. Multiple businesses thrived by supplying farming implements, feed stores, blacksmithing services, and livestock products. Among those businesses was the Newark Cash Feed Store on the west side of Elkton Road near the intersection with Amstel Avenue, which sold Pratt and Eschelman's horse, stock, and chicken feed. The success of the Curtis Paper Mill and the vulcanized fibre industry shifted the Newark economy from primarily agriculture-based to industry-based. Many of these agriculture-based businesses survived until the 1940s and 1950s, when suburban development, coupled with industrialization, made large-scale farming in the surrounding area difficult.

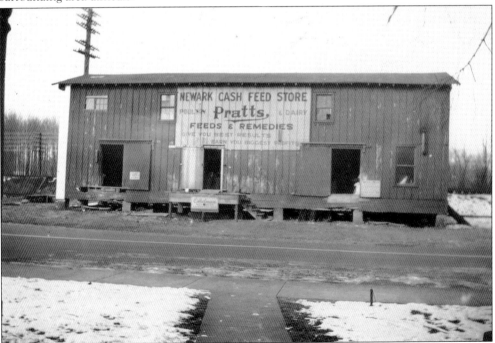

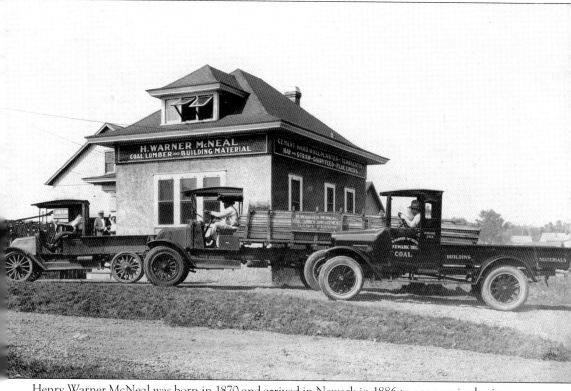

Henry Warner McNeal was born in 1870 and arrived in Newark in 1886 to open an ice business. Originally from Bell Hill, Maryland, McNeal constructed a large plant near the Curtis settling pond, which was later destroyed by fire. In 1902, he entered the coal business, and shortly thereafter, added a lumber business. McNeal built a plant on the former site of the Jacob Thomas Wallpaper Company that had burned down in 1918. McNeal sold his coal and lumber business to the E.J. Hollingsworth Company in 1927. Over the course of many years, McNeal built 15 houses, largely on Cleveland and Prospect Avenues, to provide housing for local workers. He was an elected member of the Newark Building and Loan Association and was an active member of both the State Banking Association and the Aetna Fire Company. McNeal died in 1939.

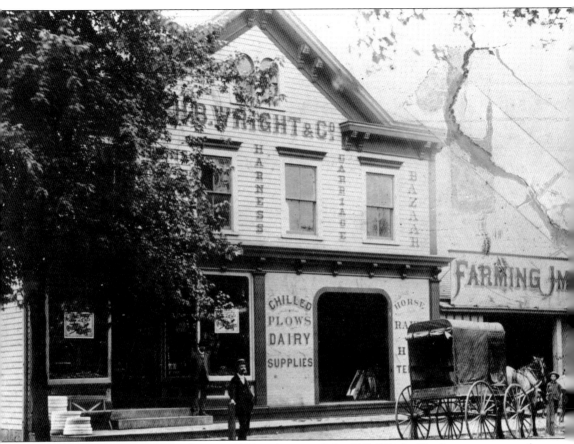

Hughes Beard Wright was born in 1856 and operated the H.B. Wright Hardware store near the corner of Main and Chapel Streets beginning in 1877. Initially located on the northeast corner of the intersection where St. John's Church now stands, Wright moved his business across the street in 1883 to the former site of his father Samuel Wright's blacksmith shop. In addition to hardware, Wright's store carried paints, oils, and varnish, as well as sporting goods and other household goods. As with many other prominent businessmen, Wright was active in civic affairs and was the second fire chief of Aetna Hose, Hook and Ladder Company, serving from 1891 to 1893, in addition to being a member of the Odd Fellows, the Newark Country Club, and a director of the Newark Building and Loan Association. Wright worked in the store until his death in 1929 and is buried in Newark Cemetery.

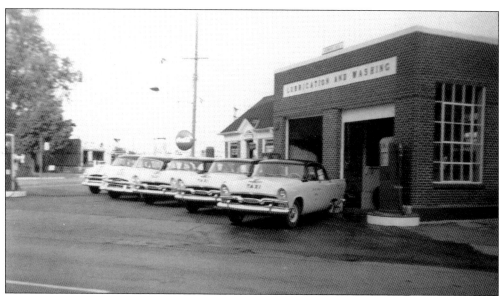

In 1931, Robert McFarlin opened the Capitol Trail Garage in Marshallton, Delaware. The garage closed around 1940, and McFarlin established the Newark Taxi Company, which served passengers throughout the 1940s and 1950s at 82 Kells Avenue. In addition, he worked at Smith's Atlantic Service Station on the corner of Main Street and South Chapel Street. A gas station remained on this corner through the 1980s. The photograph of the service station was taken in October 1956, while the image of McFarlin was taken in February 1958. In later years, McFarlin opened a service station on Capitol Trail, and he died in 1970.

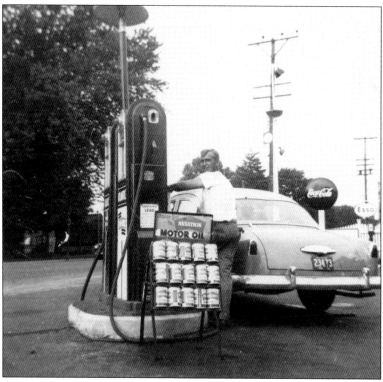

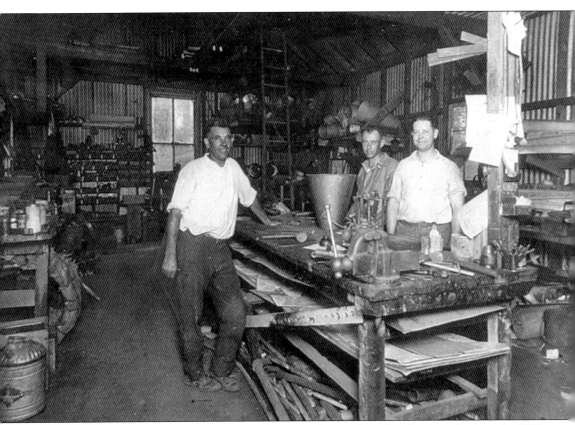

Daniel Stoll was born in 1881 in Pennsylvania and started in the plumbing business in 1901. He operated a plumbing and heating business from behind his home on Main Street, which was located next to the John Evans house near the intersection with North College Avenue. Stoll is pictured here in his shop with Ben McCormick and Horace Null. Stoll performed plumbing and heating work for both the University of Delaware and the City of Newark. In the 1920s, he was contracted to install sewers along Newark's streets, and in 1926, Stoll completed the plumbing and heating for a new dining hall constructed on the University of Delaware campus. Stoll also serviced customers in Elkton, Maryland, and regularly advertised his business in the *Newark Post*. Stoll retired in 1958 after over 50 years of serving New Castle County.

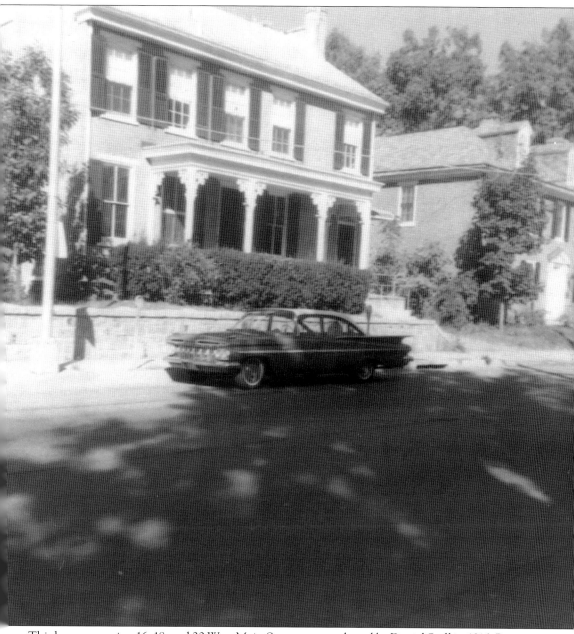

This home spanning 16, 18, and 20 West Main Street was purchased by Daniel Stoll in 1916. Prior to this purchase, Stoll and his family lived on Delaware Avenue. Stoll was active in community organizations and was a member of Aetna Hose, Hook and Ladder, serving as fire chief in 1924 and later as president of their board of directors. Stoll was an early member of the Newark Country Club, and in 1937, he was elected first vice president of the Lions Club. In addition, he served on the town's board of health and the Light and Water Committee. In 1966, Stoll's home was purchased by the University of Delaware and was eventually demolished to make way for Willard Hall, which now houses the School of Education. Stoll moved to a home on Briar Lane, where he died in 1967.

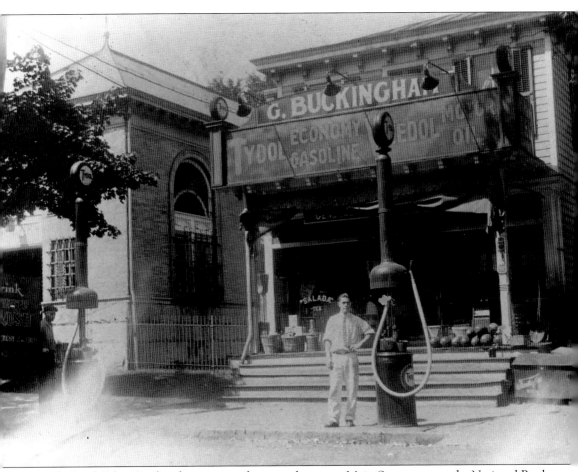

Richard Gilpin Buckingham operated a general store on Main Street next to the National Bank of Newark for approximately 20 years. Originally from Corner Ketch, Delaware, Buckingham moved to Newark in 1927 and was one of the first graduates from Goldey College in Wilmington, Delaware. This photograph was taken in 1928 and features employee Roy Nichols. Buckingham served as a member of the town council and the Light and Water Committee during the 1920s, and he served on the Board of Directors of the Farmers' Trust Company in 1928. In the mid-1930s, the family moved back to Corner Ketch, but Buckingham continued operating the store. Buckingham frequently advertised in the *Newark Post*, and multiple advertisements indicate that he was also the owner of the Farmers Feed Market. Later, he worked on the University of Delaware custodial staff. He died in 1950.

This image of homes along Prospect Avenue includes the home of Charles Henry Ellison, a machinist who resided here in the 1910s. Ellison moved to 107 North College Avenue by 1920. He died in November 1921 and left his home to his daughter Jennie. Ellison's son Elmer served many years as fire chief of Aetna Hose, Hook and Ladder Company.

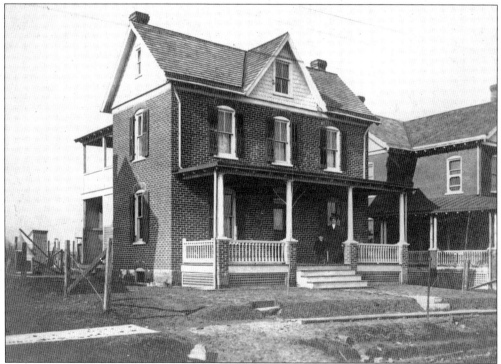

Frank Garatwa was born in Hungary in 1876 and immigrated to the United States in 1905. Garatwa initially worked at the Curtis Paper Mill but, by 1920, had purchased this home at 105 North College Avenue and begun working for the University of Delaware as a janitor. He held that position for over 20 years. He also owned a rental property at 714 Academy Street. Garatwa died in 1946.

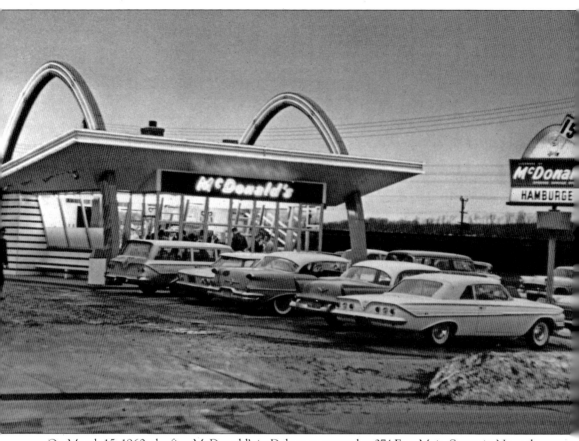

On March 15, 1960, the first McDonald's in Delaware opened at 374 East Main Street in Newark. Illinois resident and entrepreneur Leonard Dukhart was offered a franchise in Newark and moved his family to Delaware to open the restaurant. Within three years, the Newark location was so popular with residents that it was in the top-100 McDonald's franchises in the country. Les Dukhart began working with his father in 1973, and the family eventually purchased a second location on Concord Pike in Wilmington, Delaware, which is operated today by Les's brother Alan. The Newark building has been remodeled four times: once in the late 1960s, when the original outdoor walk-up style building was replaced; in 1976 following a gas explosion, which included the installation of a drive-through window; in 1995, to include a children's play area; and most recently, in 2014, with a modern configuration. Today, the family owns 11 McDonald's restaurants in Pennsylvania and Delaware, and the Newark McDonald's remains a family business.

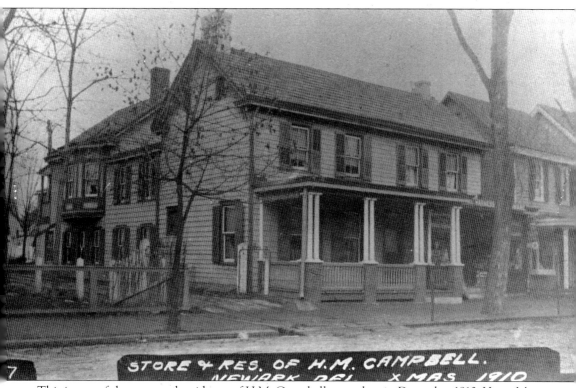

STORE & RES. OF H.M. CAMPBELL.
NEWARK DEL XMAS 1910

This image of the store and residence of H.M. Campbell was taken in December 1910. Harry M. Campbell operated a dry goods and grocery store on Main Street beginning shortly before the turn of the 20th century. In 1893, the store suffered a fire but remained in operation. In addition to being a popular businessman, Campbell served on the town council. Campbell owned additional properties around Newark, including a home on Prospect Avenue. Campbell was born in Maryland on October 28, 1864, died on October 31, 1911, and was buried at Head of Christiana Church. Following his death, ownership of the store and home was transferred to his wife, Jennie. In 1915, the building was destroyed by fire while being rented to a tenant. Jennie Campbell lived on Amstel Avenue until her death in 1955.

William Huggins was a well-known house painter who lived at 24 West Delaware Avenue in the 1930s and 1940s. This image of Huggins and his daughter Pearl was taken sometime in the 1900s, before Huggins moved to Newark. Huggins died in 1946 and is buried in Pencader Cemetery, Glasgow, Delaware.

This home, located near the corner of Corbit and West Main Streets, demonstrates the multi-family architecture that exists throughout Newark. Corbit Street was named for members of the Corbit family, who emigrated from Ireland and were established in Newark by the time of the 1860 census. Corbit Street was an important link between the New London Road African American community and West Main Street.

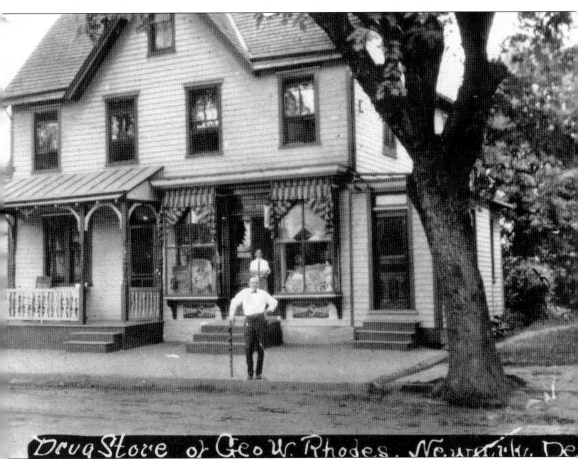

Drug Store of Geo W. Rhodes. Newark, De

This image, taken between 1910 and 1912, depicts Rhodes Drug Store at its original location at 168 East Main Street. Owner and pharmacist Dr. George W. Rhodes came to Newark in 1895 and worked in Dr. J.B. Butler's apothecary shop on Main Street near the intersection with Chapel Street. After graduating with a pharmacy degree, Rhodes purchased Butler's shop in 1910. He purchased Frazer's Drug Store at 38 East Main Street near Delaware College in 1912, and in 1917, he combined two buildings to create a larger, more spacious store. The expanded Rhodes Drug Store included an ice-cream shop and soda fountain with counter stools and table seating. The building remained a drugstore until 1988 and is now home to Newark Deli and Bagels. In addition to operating the drugstore, Rhodes served as both a representative and a senator in the state legislature; on several civic committees, including on the board of directors for the Newark Trust and Safe Deposit Company; and as head of the state pharmacy board.

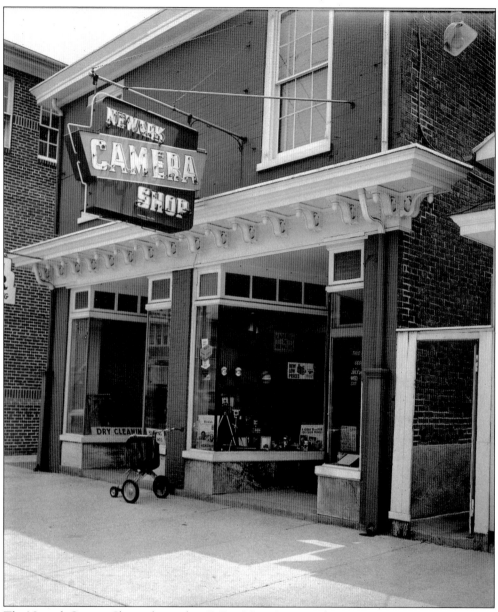

The Newark Camera Shop is located at 63 East Main Street and occupies a portion of the bottom floor of the International Order of Odd Fellows building. The first Odd Fellows Lodge, named the Oriental Lodge No. 12, was established in Newark was established on February 11, 1847, and is one of the oldest existing Odd Fellows lodges in the country. A fraternal organization that encourages a sense of community, the lodge hall was constructed on Main Street in 1851. The first floor was designed for retail space with a meeting room on the second floor. In 1882, the lodge had 86 members. The Newark Lodge continues to meet at this location and perform charitable acts in the community. While a variety of businesses have occupied a portion of this retail property, the Newark Camera Shop has remained at this location since 1935.

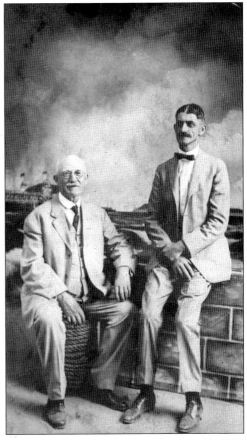

Ernest Frazer (pictured at right with bow tie) was born in Fair Hill, Maryland, in 1874. He and his wife, Evelyn, operated a grocery store and maintained a home on West Main Street. In addition, Frazer owned property on Cleveland Avenue as well as several other rental properties. The Frazers had three daughters: Anna, Agnes, and Catharine. Pictured on the left with Ernest is William Barton. In 1920, Frazer and Barton traveled to the west coast and back. Evelyn was an active member of the Daughters of the American Revolution until her death in 1943. This photograph below depicts her on the porch of her home in 1920.

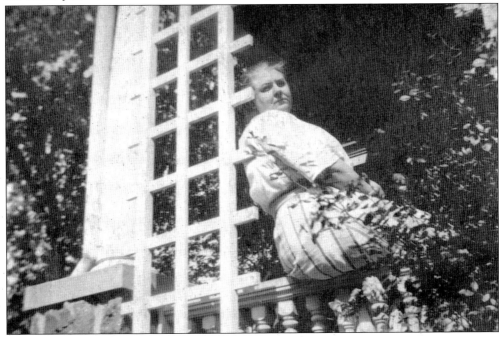

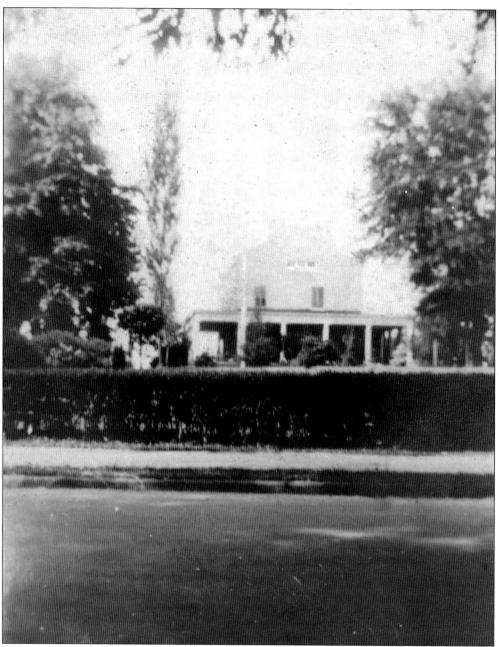

Eben Frazer was born in Elkton, Maryland, in 1853 and moved to Newark around 1890. A trained pharmacist, Frazer operated a drugstore at numerous sites along Main Street for approximately 25 years. Frazer purchased this home, Belmont Hall, from the Blandy family and performed extensive renovations around the turn of the 20th century. Active in civic affairs, Frazer was a member of the International Order of Red Men and the Presbyterian Church. He served as Newark's mayor for 12 years, beginning in 1917 until his death in 1929, and oversaw improvements to streets and utilities. Prior to his tenure as mayor, he was a member of the town council and served as president of the Farmers' Trust Company. Frazer also served on the Board of Trustees of the University of Delaware for 16 years, beginning in 1913 until his death.

The Wright family was a prominent Newark family. Samuel J. Wright was born in 1851 and joined his father's coal and lumber business. He married Isabel Pilling, and together they had three sons and two daughters. In 1895, Wright joined the American Hard Fibre Company and, in 1906, founded the Continental Fibre Company, which later became a family venture. Pictured to the right in the late 1880s is Wright's son Norris. Below are two of his grandsons, Brinton and S.J., in a photograph taken in 1933. Members of the Wright family were active not only in Newark's industries but also in civic affairs for many generations.

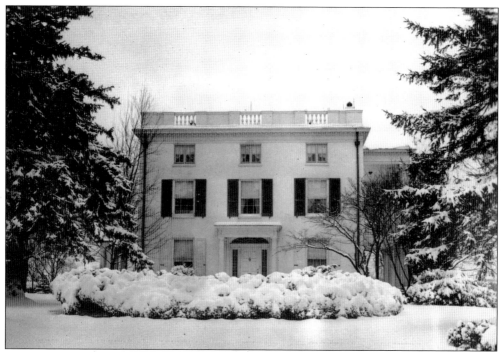

The Granite Mansion was built between 1844 and 1845 for James Miles, a Newark postmaster and state representative. In 1890, the home and surrounding 150 acres were purchased by Jennie Jex, who operated a dairy farm at the location for more than 30 years. In 1921, the property was bought by the newly created Newark Country Club, which then sold the mansion and fifteen acres to Norris Wright in 1924. Wright made extensive renovations to the property. The home and surrounding property were purchased by the First Presbyterian Church in 1955, and the mansion was demolished in 1988.

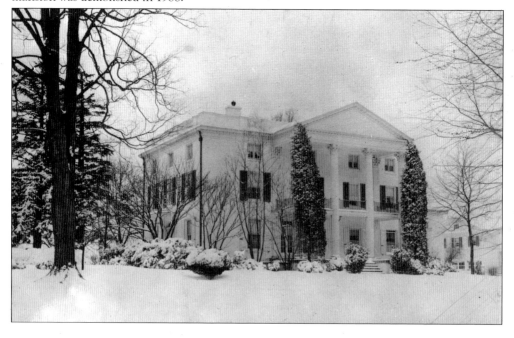

Four

TRANSPORTATION
AND INDUSTRY

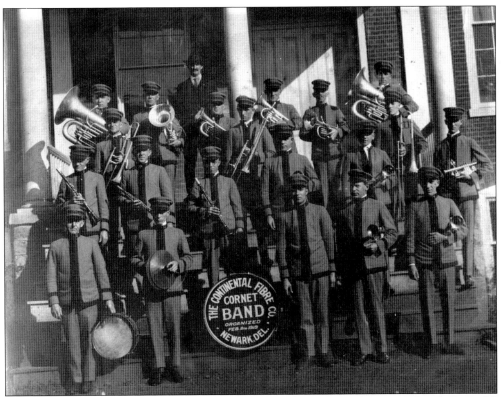

The Continental Fibre Company's Cornet Band was organized in February 1919 with Samuel J. Wright, president of the company, as its promoter. By 1924, the band counted 22 members and performed at the dedication of Newark's new bandstand on the lawn of the Academy Building on Main Street.

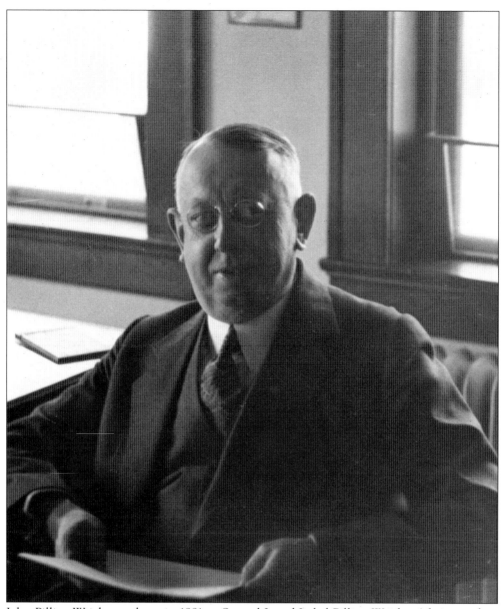

John Pilling Wright was born in 1881 to Samuel J. and Isabel Pilling Wright. After attending Newark High School, Wright established the American Hard Fibre Company in 1898 on the former site of the Dean Woolen Mill. He became manager of the American Vulcanized Fibre Company in 1901, following a merger with three other vulcanized fibre companies. In 1906, Wright founded the Continental Fibre Company at the corner of Delaware Avenue and Chapel Street and served as the company's vice president. Wright also served as president of Delaware Rayon Company. An active community member, Wright served on the Board of Trustees of the University of Delaware from 1934 until 1946. In addition, he served as president of the Newark Trust Company and the Newark Country Club and was affiliated with the Aetna Hose, Hook and Ladder Company. Wright constructed a large home at 47 Kent Way in 1905. Following his death in 1947, his widow transferred ownership of the property to the University of Delaware in 1961. Today, the home serves as the university president's house.

Norris Nathan Wright was the second son of Samuel J. Wright. Born in 1886, Wright attended Newark schools and began working in his father's plant. Following the death of his father in 1926, he became vice president and sales manager of the Continental Diamond Fibre Company. Like other members of the Wright family, Norris was active in Newark civic organizations and affairs, advocating for the extension of gas lines through Newark, serving as a state senator from 1935 to 1939, and serving on the town's streets and police committees in 1943. Norris was a founding member of the Newark Country Club and director of the Newark Trust Company. He was an active member of Hiram Lodge No. 25 and donated land for their location on Delaware Avenue. He and his wife, Fleta, owned the Granite Mansion on West Main Street and were very involved in Newark's social life until his death in 1951.

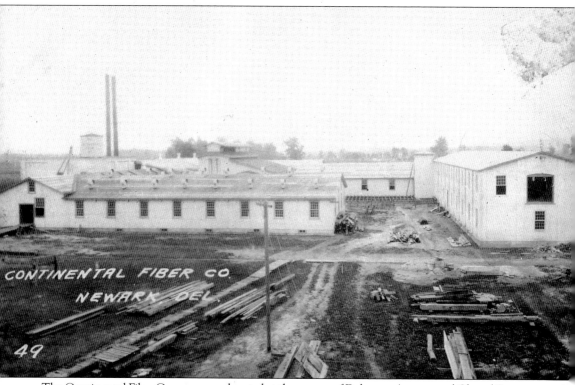

The Continental Fibre Company was located at the corner of Delaware Avenue and Chapel Streets. Established in 1906 by Samuel J. Wright and his son J. Pilling, Continental Fibre merged with Diamond State Fibre to become Continental Diamond Fibre in 1929. Initially a family company, eldest brother J. Pilling served as president, middle brother Norris as vice president, and youngest Ernest as treasurer. The company prospered from the 1930s through the 1950s and expanded to include locations in South Carolina, England, and France. As technology advanced, the company's sales began to decline, and in 1962, the company was purchased by the Budd Polychem Company, which continued to operate the plant until 1972. After several other occupants, the plant was closed in 1982. In 1998, the location was sold to a developer, and the plant was demolished in 2000. (Courtesy of Mary Torbey.)

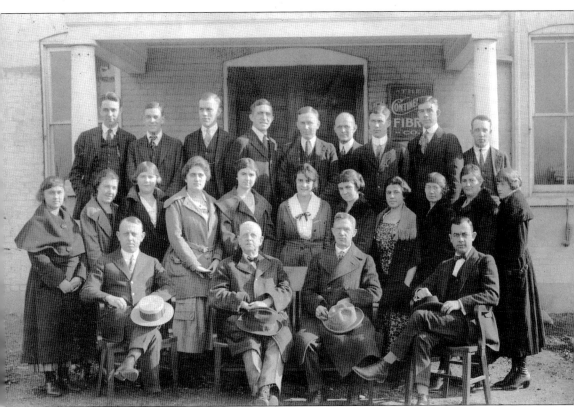

This image of the Continental Fibre Company officers and staff was taken sometime in the early 1920s before the death of company president Samuel J. Wright in 1926. Pictured from left to right in the first row are J. Pilling Wright, Samuel Wright, Ernest Wright, and Norris Wright. Office staff for the company included not only secretarial staff but also advertising, employment, and shipping staff. After merging with Diamond State Fibre Company in 1929, the company employed over 2,000 workers throughout several plants. During World War II, the company was fully engaged in producing parts, material, and equipment vital to the war effort and actively advertised in the *Newark Post* to hire additional local workers. The company encouraged employees' social interactions and established a company cornet band, baseball team, and bowling team in addition to hosting an annual Christmas party, often held at the Newark Country Club.

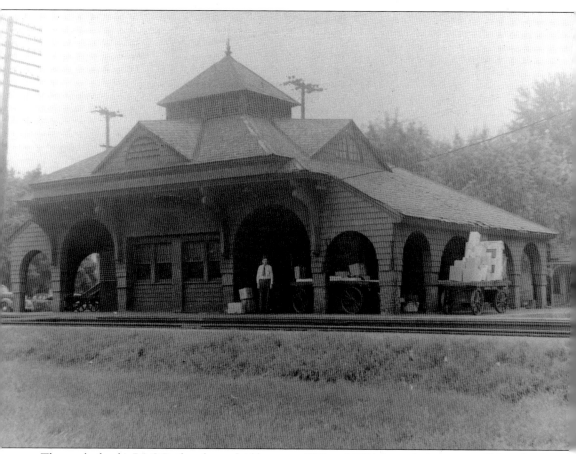

The tracks for the B&O Railroad were laid between 1883 and 1884 through the center of Newark, crossing Main Street at the Deer Park and running parallel to the town's northern border. Local landowner Rathmell Wilson sold property to the Baltimore & Philadelphia Railroad to establish a railroad and station on Elkton Road, now South Main Street, near the intersection with Delaware Avenue. The B&O provided both passenger and freight service and was essential in encouraging companies, such as the Jacob Thomas Wallpaper Company, to invest in Newark. In addition to the station, there were also baggage and freight buildings and two railroad maintenance buildings. Passenger service between Wilmington and Baltimore included a Newark stop when the station opened. The station was replaced in 1945 by a newer station, and passenger service was suspended in 1958. Today, the tracks continue to be used for freight service by the CSX Railroad.

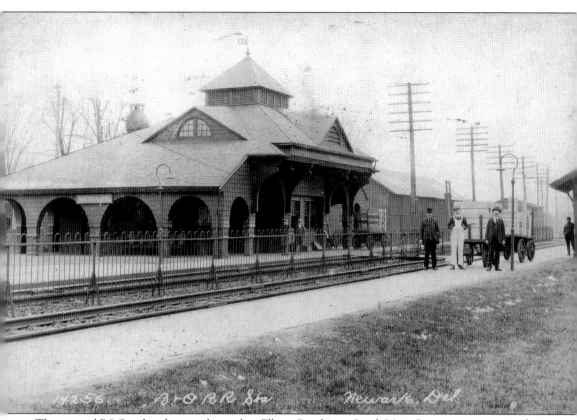

The original B&O railroad station located on Elkton Road, now South Main Street, was constructed in 1886. It was designed by noted Philadelphia architect Frank Furness, who designed more than a dozen railroad stations in the area, including Wilmington's Joseph R. Biden Jr. Railroad Station. Especially active during the late 19th and early 20th centuries, Furness was one of the most highly paid architects of the era. Furness designed stations for three different railroad companies: the Reading Railroad, the Baltimore & Ohio, and the Pennsylvania Railroad. The station shown here was demolished in August 1945 to make way for a new, more modern passenger station. Passenger and freight service remained uninterrupted, and the new station, which cost approximately $20,000 to construct, opened in November 1945. The building was designed to resemble many of Newark's homes and college buildings and had a waiting room, freight and parcel room, and washrooms. (Courtesy of Mary Torbey.)

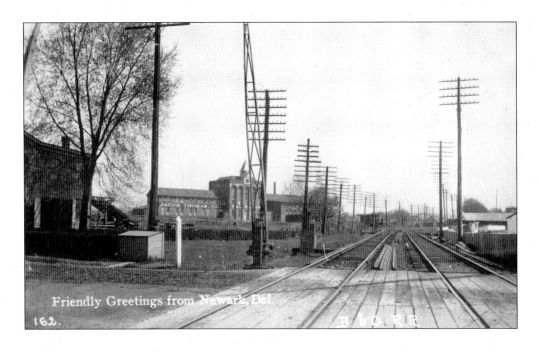

The Jacob Thomas Wallpaper Company was established in Newark in 1897 in the building that once housed the Knauff Organ Factory. Jacob Thomas was a German immigrant who maintained a home on Main Street. Located along the north side of the B&O Railroad tracks between New London Road and North College Avenue, the company employed approximately 100 people. On January 11, 1918, the building caught fire and burned to the ground. The Thomas family sold their home and left Newark in 1915. The site later became home to H. Warner McLean's coal and lumber company and is now home to the University of Delaware's Studio Arts Building.

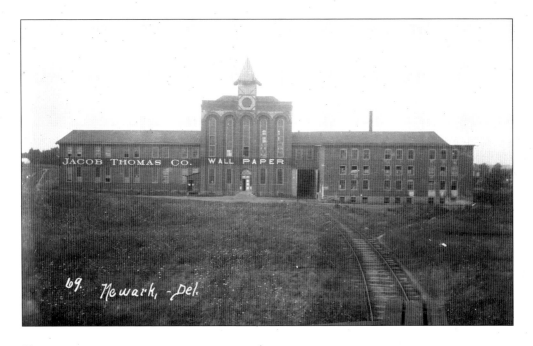

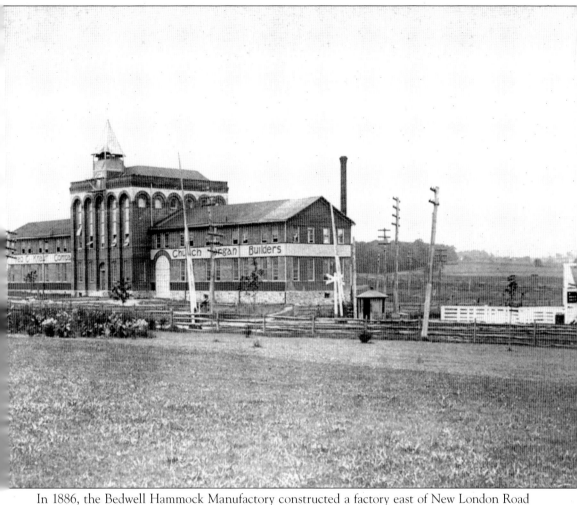

In 1886, the Bedwell Hammock Manufactory constructed a factory east of New London Road and just north of the B&O Railroad tracks. In 1889, it was taken over by the Theodore C. Knauff Organ Company. An organ builder and former choir director at St. Mark's Episcopal Church in Philadelphia, Theodore Christian Knauff was born in 1847 and later moved to Newark to establish his business. The factory contained an electric power plant that both powered the factory and supplied electricity to operate the town's streetlights. By 1892, the company was bankrupt, and the city was offered the option of purchasing Knauff's generator in order to be able to keep Newark's streets lit. To prevent future issues, the city council voted to construct a building next to the water pumping plant and allow Pennsylvania General Electric to relocate the power plant. Beginning in 1897, the Jacob Thomas Wallpaper Company occupied the building until it was destroyed by fire in January 1918.

The covered bridge on Paper Mill Road spanned the White Clay Creek near Curtis Paper Mill and the American Vulcanized Fibre plant. These images depict two different views of the bridge, which was constructed in 1861 as a replacement for the bridge built in 1817 when the mill was owned by Thomas Meeteer. The original bridge may have been replaced due to deterioration both as it weathered and because of increased traffic to the paper mill during the Civil War. In 1949, the covered bridge was replaced with a more modern, concrete bridge capable of handling an increasing number of automobiles. The Vulcanized Fibre Company is visible in the image above. The Koelig Farm, the current site of the Newark Reservoir, is visible to the right of the image below.

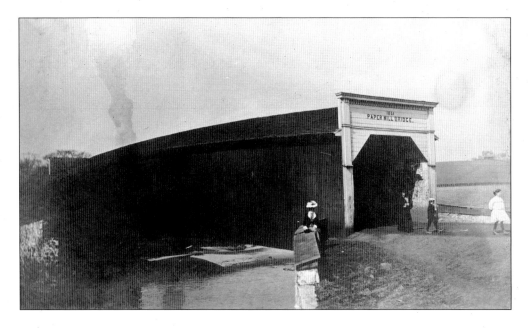

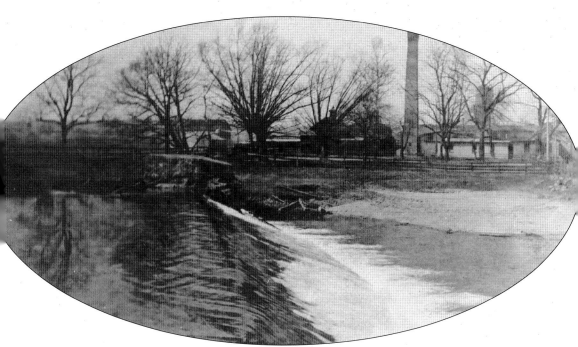

Thomas Meeteer founded a paper mill on this site in 1789. In 1848, Massachusetts natives George and Solomon Curtis rebuilt Meeteer's mill and established the Nonantum Mill, known locally as the Curtis Paper Mill, to produce high-quality paper. In 1850, George left the business, and his brother Frederick joined the company. They operated the business together until Frederick's death in 1884, and Solomon continued in his role until retiring in 1887. Solomon transferred ownership to both his sons and Frederick's. The company was owned exclusively by Curtis family members until 1911, when the company was incorporated. In 1926, Alfred Curtis retired and sold the company to outside investors who kept the name. In 1977, the company was sold to the James River Company, which continued to operate the mill until its closure in December 1997. At that time, it was the oldest operating paper mill in the country. The City of Newark purchased the property in 1999 and converted it into Curtis Mill Park. By 2007, all remnants of the mill buildings were demolished, but two pillars in the park were constructed out of recycled brick and made to resemble the mill's iconic smokestack.

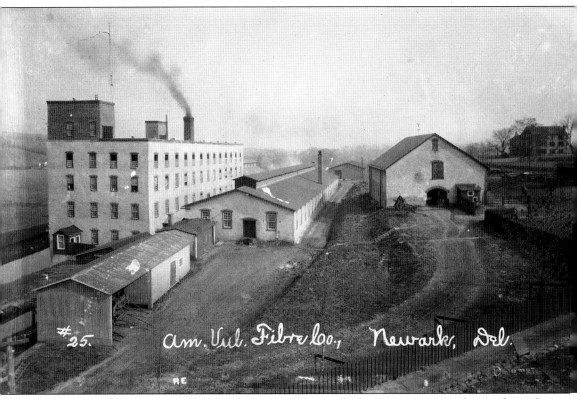

#25. Am. Vul. Fibre Co., Newark, Del.

This view of the eastern end of the American Vulcanized Fibre Company was taken in the early 1900s. Founded in 1894 by John Pilling (a partner in the Dean Woolen Mill that had previously occupied the location) and Samuel Wright, the American Vulcanized Fibre Company plant became part of the National Vulcanized Fibre Company in 1922, when American merged with Kartavert Manufacturing Company, Laminare Fibre Company, and Vulcanized Fibre Company. Three of these four companies were based in northern Delaware, leading to Delaware being referred to as the "Vulcanized Fibre Capital of the World." The company produced vulcanized fibre products that were used in luggage, electrical and plumbing materials, and other products. It maintained a main office in Wilmington with manufacturing sites in Wilmington, Newark, and Yorklyn, Delaware and Kennett Square, Pennsylvania. In 1906, Samuel Wright left the company to form Continental Fibre Company with his eldest son, J. Pilling Wright.

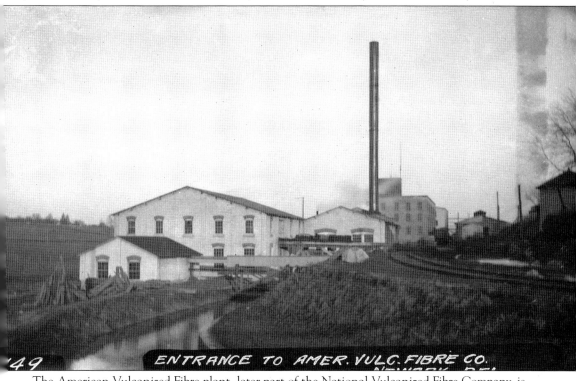

'49 ENTRANCE TO AMER. VULC. FIBRE CO.

The American Vulcanized Fibre plant, later part of the National Vulcanized Fibre Company, is Newark's oldest industrial site. National Vulcanized Fibre Company was a Yorklyn, Delaware–based company. The Newark plant employed many residents until it ceased operation in 1991. From the 1930s through the 1960s, demand for vulcanized fibre products flourished; however, as the modern plastics industry developed, the need for vulcanized fibre decreased. The company was actively involved in the Newark community, sponsoring talks and events, advertising in the *Newark Post*, and contributing to local organizations. Following its closure in 1991, the plant remained vacant for several years and burned in January 1993. In the early 2000s, after extensive environmental cleanup, the plant was developed by the Lang Development Group for office, retail, and residential space. An 1853 stone mill building and three other buildings were preserved and renovated.

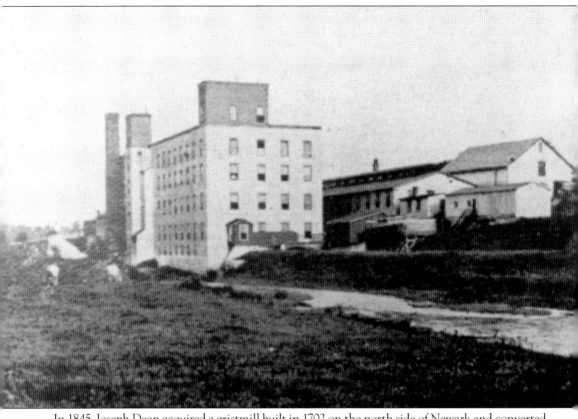

In 1845, Joseph Dean acquired a gristmill built in 1702 on the north side of Newark and converted it for spinning wool. In 1847, Dean added his son William as a partner and named the firm Joseph Dean and Son. They manufactured types of wool cloth and blankets, much of which was destined for use by the Union army in the Civil War. Following his father's death in 1861, William partnered with John Pilling, an area mill manager. Dean and Pilling successfully expanded the mill as business increased, and in 1882, they decided to incorporate, forming the Dean Woolen Company. On December 25, 1886, the mill caught fire and burned to the ground. Local newspapers reported that 272 people were employed there, but 800 Newark residents, more than one-third of the entire population, were dependent upon the mill for support. Dean and Pilling decided not to rebuild the mill, so the property remained vacant until 1894, when John Pilling and Samuel Wright established the American Hard Fibre Company on the site. The plant produced vulcanized fibre products until 1991. In 1997, the property was purchased and has been developed for office space, apartments, and a restaurant.

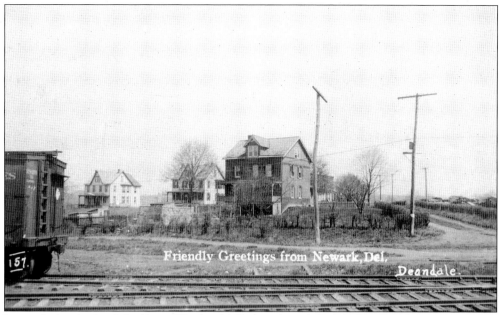

Located just south of the Dean Woolen Mill, the "Deandale" neighborhood was constructed on a plot of land initially owned by Joseph Dean, who hoped to found his own town. Deandale contains a series of streets and homes constructed to house the mill's employees and their families. Though many streets were named for members of Dean's family, the neighborhood also includes a street now named Woolen Way, a reference to Deandale's origins. These homes are now largely rented by University of Delaware students. (Courtesy of Mary Torbey.)

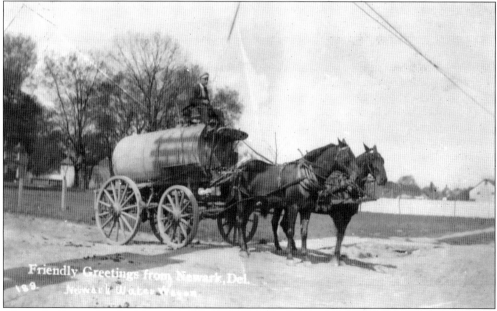

Alexander Perry served as Newark's supervisor of streets beginning in 1886 until his death in 1914. His duties included watering Newark's unpaved roads to alleviate dust. Newark's water wagon was sponsored by the Newark New Century Club. He is pictured here around 1900, driving the water wagon. (Courtesy of Mary Torbey.)

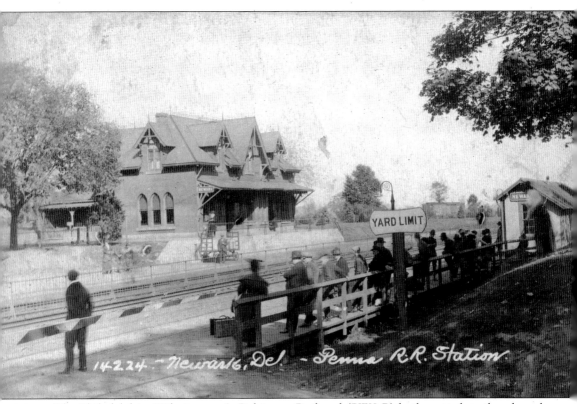

14224 - Newark, Del. - Penna R.R. Station.

The Philadelphia, Wilmington & Baltimore Railroad (PW&B) built a single railroad track almost a mile south of Main Street in 1836, and the first train passed through Newark on its trip between Wilmington and Elkton, Maryland, on January 9, 1837. The PW&B was formed when the Wilmington & Susquehanna Railroad Company, the Philadelphia & Delaware County Railroad Company, the Baltimore & Port Deposit Railroad Company, and the Delaware & Maryland Railroad Company merged. The merger of these four companies allowed for continuous rail service from Philadelphia to the Susquehanna River in Maryland. Newark's original train station was constructed on the southwest side of the railroad tracks in the 1840s, and in 1841, James Martin constructed Depot Road (now South College Avenue) leading from the station to Main Street. By 1861, railroad traffic had increased, and a second railroad track was laid.

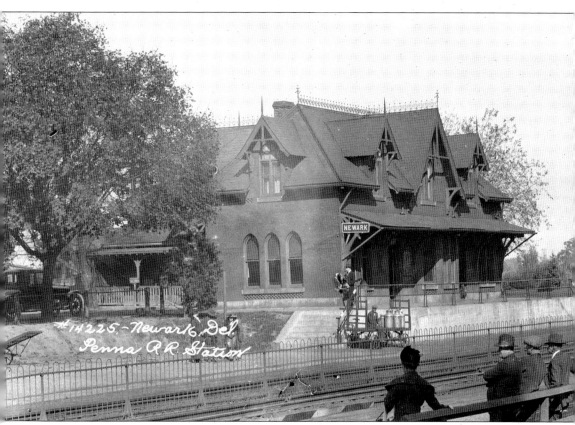

Newark's first railroad station was demolished in 1876, and a new station was constructed on the northeastern side of the tracks in 1877. A water tower to supply power to steam locomotives was built north of the station. In 1902, the PW&B merged with the Pennsylvania Railroad. In 1968, the Pennsylvania Railroad merged with the New York Central and created the Penn Central Transportation Company, and by 1971, passenger services were operated by Amtrak. In 1974, Amtrak closed the station but kept the building occupied as a freight office. In 1984, the City of Newark purchased the property, and renovations began in 1986. In 1989, the station became home to the Newark History Museum. The Southeast Pennsylvania Transportation Authority (SEPTA) established service to Newark in 1997. In 2017, construction began on a new train station on the southeast side of the tracks near the site of the original 1840s train station. (Courtesy of Mary Torbey.)

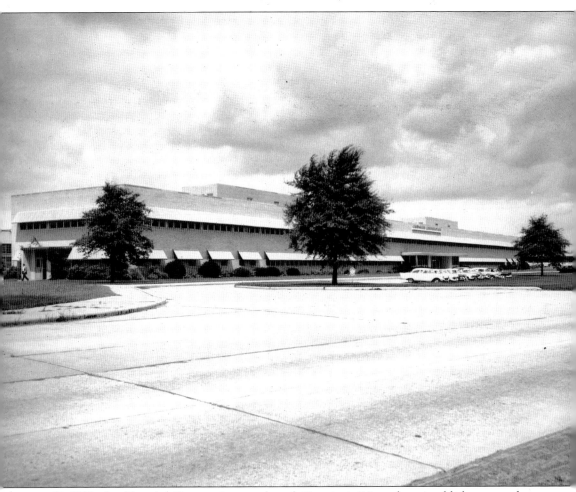

In 1938, the Chrysler Corporation purchased 65 acres in Newark to establish a parts depot. Ground was broken in 1951 to construct a plant to produce tanks needed to support the United States' involvement in the Korean War. Following the end of the war, construction began in 1956 on a Plymouth auto plant, with the first car coming off the assembly line on April 30, 1957. The plant produced 67,000 cars in its first year and employed 4,300 people. In 1965, the Newark plant produced its millionth car. Employment reached its peak in 1978 with 5,500 employees, but by 1994, employment dropped to 3,400 as models such as the Spirit and Acclaim were phased out of production. A decade later, in 2004, the plant was upgraded to produce the Dodge Durango; however, a decrease in sales and an increase in gas prices contributed to Chrysler's announcement in 2007 that the Newark plant would close in 2009. In June 2008, the plant was listed for sale, and it officially closed on December 31 of that year, after having produced almost seven million automobiles.

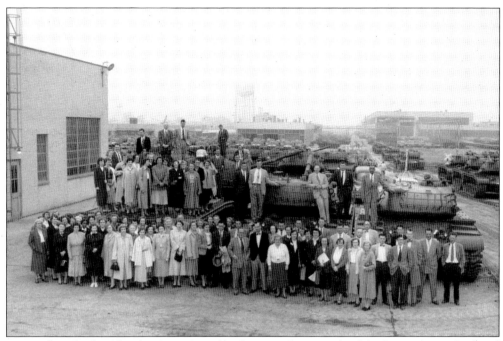

In March 1951, the Chrysler Corporation broke ground just south of the Pennsylvania Railroad tracks for a plant to produce the M48 Patton tank as the country became involved in the Korean War. By mid-1952, about 3,000 workers began full-scale tank production, which lasted through the end of the war in 1953. A five-year phased plan brought tank production at the plant to an end by 1961, with a shift to automobile production beginning in 1957. Pictured here are some of the nearly 12,000 tanks produced by the plant. In addition, the plant also produced approximately 300 T-43 heavy tanks.

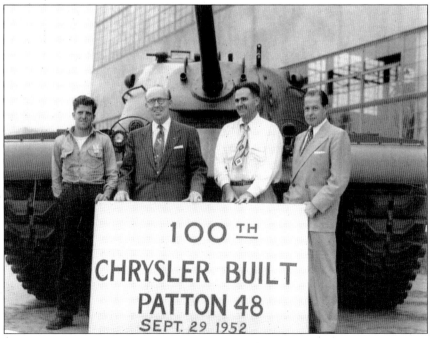

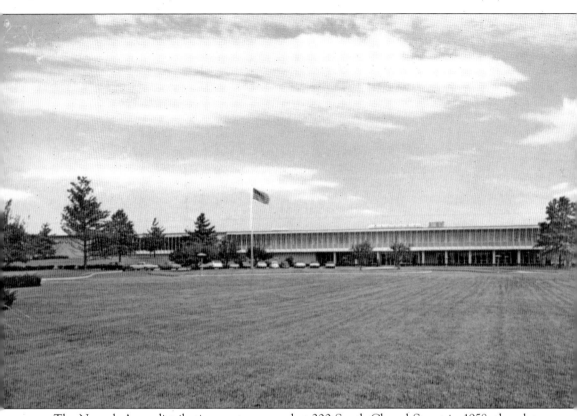

The Newark Avon distribution center opened at 200 South Chapel Street in 1958, then later moved to a facility on Ogletown Road, just outside of the city boundary. The facility included a warehouse that processed and shipped product orders from Avon representatives. These products included hair care, shaving creams, insect repellents, and air fresheners, in addition to other cosmetic products. At its peak, more than 700 people were employed, and the company played a significant role in the city's economy. In January 2007, the company announced that the distribution center would close by mid-2009. At the time of its closure, more than 350 people were employed at the center. The site was rezoned in 2015 to allow for commercial rather than industrial use and is currently being developed for a combination of residential, retail, and office spaces after years of vacancy.

Five

RELIGION
AND COMMUNITY

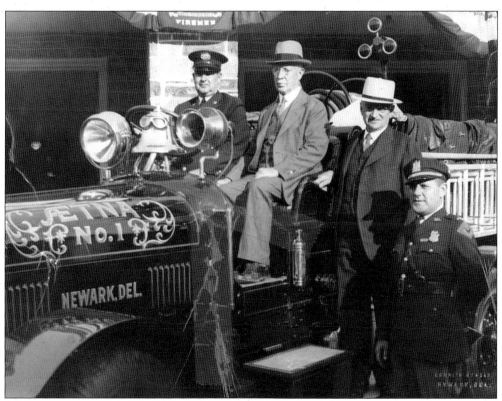

This image depicts Ira Shellender on the far left. Shellender was a member of Aetna, Hose, Hook and Ladder Fire Company for 36 years. Shellender owned the Ira C. Shellender Funeral Home at 254 West Main Street from 1910 until his death in 1947. Extremely active in civic affairs, in addition to Aetna, Shellender was a member of the Newark Lions Club, the chamber of commerce, the Knights of Pythias, and the First Presbyterian Church.

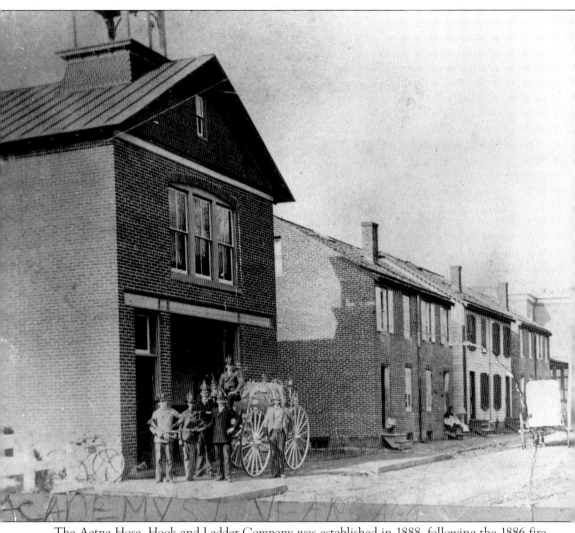

The Aetna Hose, Hook and Ladder Company was established in 1888, following the 1886 fire that destroyed the Dean Woolen Mill, with Joseph T. Willis as chief and William Simpers as president. This 1905 image depicts the firehouse constructed in 1890 on the west side of Academy Street between Main Street and Delaware Avenue. Depicted here are a volunteer crew and hose wagon. By January 1904, membership had doubled, and in November of that year, a second hose wagon was purchased to meet the needs of the growing community. Between 1900 and 1910, the company added significant amounts of equipment, including 900 feet of hose and six nozzles, in addition to equipment for the men, such as boots and fire hats. This equipment was funded by dues from members and an annual appropriation from the town council.

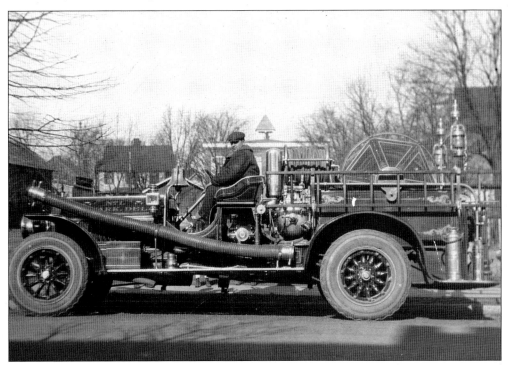

Aetna was among the first fire companies in the state to purchase a motorized apparatus. Received on September 6, 1913, the Thomas engine pictured above cost $7,500. Throughout the 1910s and 1920s, the fire company held a series of carnivals to raise funds for necessary materials. In 1921, a new Stutz 750 gallon pumper was purchased, but due to a lack of space, the new truck was housed by the Goodwill Fire Company in New Castle, Delaware. In 1925, a Seagraves engine was purchased to replace the original Thomas engine that was no longer operational. The new engine was received in February 1926.

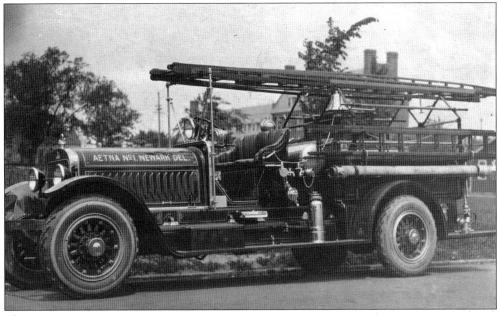

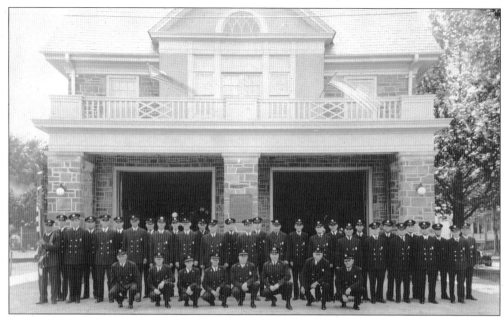

In 1921, the Trustees of Newark Academy offered Aetna ground on the corner of Academy Street and Delaware Avenue for the construction of a new firehouse. The original firehouse had been constructed on the opposite side of Academy Street in 1890 and did not have sufficient room for the growing company. The groundbreaking for the new building was held in spring 1922, and the station was occupied in July 1923. It originally consisted of two bays, pictured above. New wings were added to both the north and south sides of the building to house additional equipment in 1941. The image below of Aetna members was taken soon after construction of the new wings was completed.

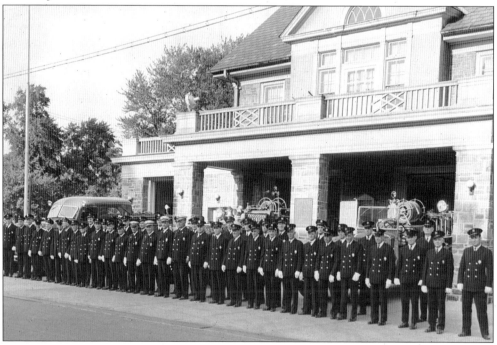

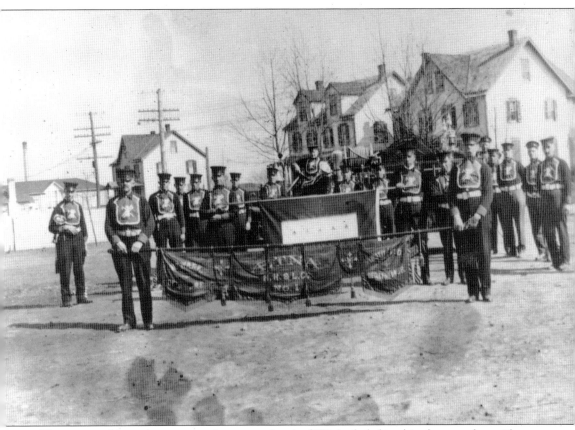

This image of Aetna's active members was taken in 1913. Included in this photograph are Elmer Ellison and E. Clifford Wilson, who both served as fire chief. E. Clifford Wilson was originally from Wilmington and came to Newark around 1900 to take over his grandfather Edward Wilson's undertaking business. In 1911, Wilson was made fire chief. He initiated the idea of a firemen's carnival to raise funds for Aetna and led the effort to acquire motorized equipment. Wilson retired as chief in 1924 and was succeeded by Elmer Ellison in 1925. Ellison worked in Newark's Water Department and eventually became superintendent. When Ellison died in 1953, he had been a member of Aetna for 59 years and served as chief for 28 years. During Ellison's tenure, additions were made to the existing fire station, and new equipment and sirens were purchased.

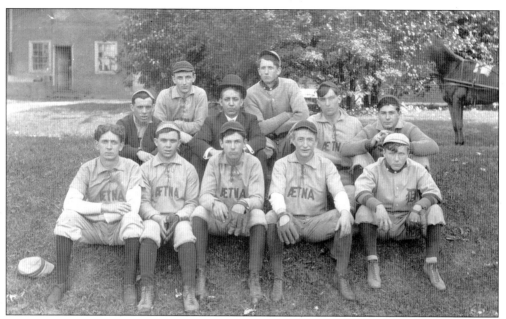

This photograph of members of the Aetna Fire Company's baseball team was taken sometime in the early 1900s. A baseball team was first established by the company in 1902 and played other amateur clubs in the area. Aetna played on the Delaware College fields and, in 1908, was considered one of the best teams in the state.

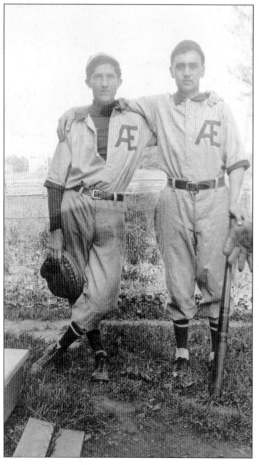

Taken sometime in the 1910s, Bill Marsey and Bill Ellison were neighbors who grew up on Cleveland Avenue, and both worked at the fibre mill. Marsey was a prominent catcher who was credited with keeping baseball going in Newark. Marsey eventually married and moved to Yorklyn.

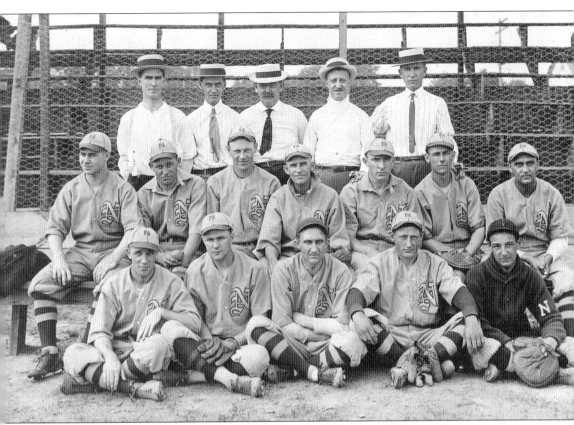

Baseball became a popular pastime in Newark as school, amateur, and minor league teams were being established throughout the state. As the sport grew in popularity, many organizations, such as Aetna Hose, Hook and Ladder Company and the Continental Fibre Company, also sponsored teams. This photograph of the Newark amateur team was taken around the 1920s when they played in the county league with teams from Five Points, Krebs, Marshallton, Yorklyn, and New Castle. Many of the amateur players had played at the high school or college level. In 1926, the Newark team was also playing teams in the Cecil County (Maryland) League. The team played home games at the University of Delaware's Frazer Field, and games were extensively reported in the *Newark Post*, often including inning-by-inning scoring. A town social affair, the Continental Band often performed at games to enliven the crowds.

These photographs of White Clay Creek School were taken in the latter half of the 1900s. The image above, dated 1905, features teacher Lillian Fredd with her students, while the bottom image depicts teacher Anna Glenn with students in 1908. White Clay Creek School served School District Number 36 and was located on Kirkwood Highway near the current location of Shue-Medill Middle School. Likely built in the early 1840s, the school was closed by the state board of education in 1919 due to low enrollment, and the school building was sold. Students who would have been assigned to White Clay Creek School were absorbed into the Newark Special School District.

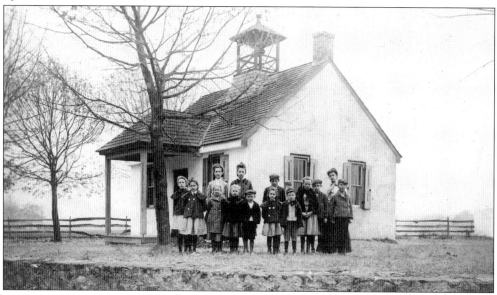

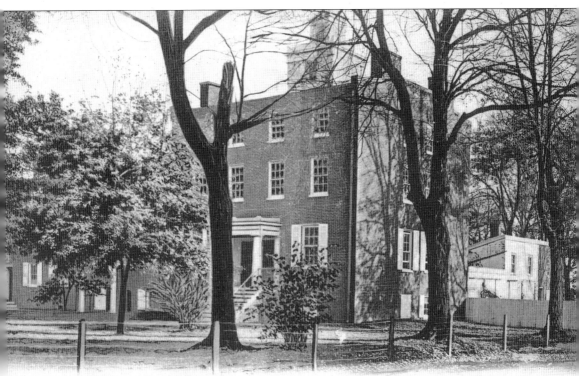

In 1743, Rev. Francis Alison established an academy in New London, Pennsylvania. In the early 1760s, Alison's academy, now under the leadership of Alexander McDowell, moved to Newark. McDowell's school occupied a stone classroom building constructed sometime prior to 1770 by the inhabitants of Newark. Shuttered during the years of the American Revolution, Newark Academy reopened in 1780 and was absorbed by Newark College in 1834. By 1839, however, the institutions had separated, and the academy reopened. In 1841, the stone building was demolished, and the right-hand section of the building pictured here was constructed. The left-hand section was built 1842, and the connecting section followed in 1872. Edgar Allan Poe lectured here on December 23, 1843. Due to the rise of public schools, Newark Academy was closed in the 1880s. Newark High School occupied its former building from 1898 until approximately 1925. Since then, the building has served multiple purposes, including the town library and city hall. Since 1976, the Academy Building has been the property of the University of Delaware and houses the Office of Communications and Marketing. (Courtesy of Mary Torbey.)

Class of

The 1913 graduating class of Newark High School was comprised of 20 students, the largest graduating class up to that time, and commencement exercises were held at the Newark Opera House. Newark's first high school was housed on the second floor of 83 East Main Street, located west of the Academy Street intersection, with elementary school classes held on the lower level. Following the closure of the Newark Academy, the high school relocated to the Academy Building. By 1919, there were 109 students enrolled in the high school, and the building was in need of repair. In 1925, the high school moved to a newly constructed building on the corner of Academy Street and Lovett Avenue, just blocks from the Academy Building. The high school remained at this location until 1955, when the current high school building opened.

This photograph of Newark elementary school students was taken in 1919. Constructed in 1884, the Newark Public School at 83 East Main Street is visible behind the students, as is the Newark Opera House on the right. This school was constructed to accommodate an increase in students and to support the merger of Newark's two previous public schools. As Newark's population increased, so too did the need for school facilities, and by 1907, a new elementary school was constructed, leading to the abandonment of the 83 East Main building. During the 1950s, the building was used by the Newark School District for Newark High School's industrial arts program, and in 1965, the building was renovated and enlarged. Throughout the 1980s and until 2004, the building served as the location for the Christina School District's administrative offices. Today, the original school building is owned by the University of Delaware and houses its bookstore.

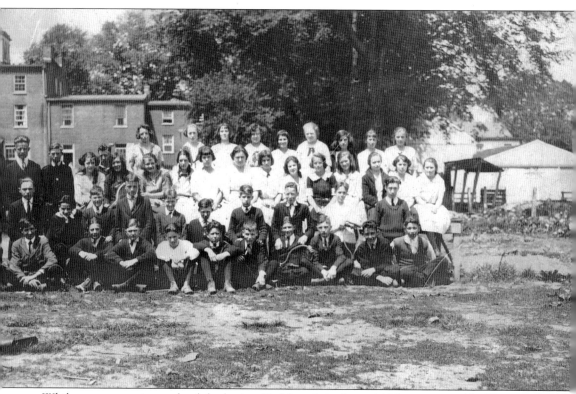

While numerous private schools had existed in Newark in the mid-19th century, public "District" schools were established in the state with the passage of the Free School Act in 1829. Newark was divided into two districts. Students residing north of Main Street attended District No. 41, located at 143 West Main Street, while those south of Main Street attended District No. 39, a brick schoolhouse located behind the current Main Street Galleria. In 1873, these two districts were combined, and all Newark students attended the Newark Public School. Elementary student classrooms were housed on the first floor, and high school students took classes on the second floor; by 1888, the school had a total of 185 students. When the high school moved in 1898, the elementary school remained at 83 East Main and expanded to both floors. A new building was constructed on Delaware Avenue near Academy Street in 1907.

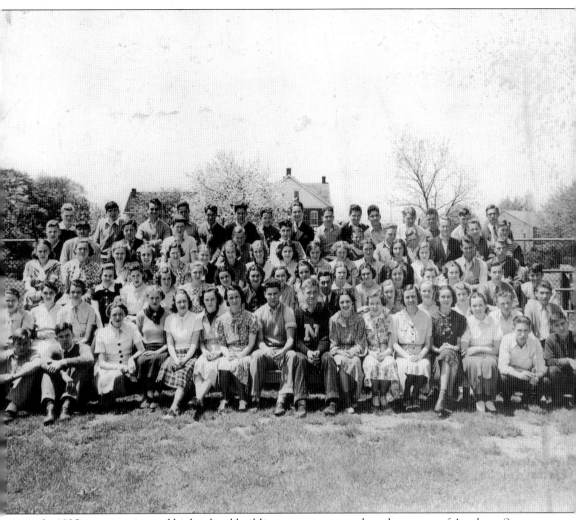

In 1925, a new junior and high school building was constructed on the corner of Academy Street and Lovett Avenue, and the Academy Building was converted to the town's library. With the move to the new building, the high school changed its name from Newark Public High School to Newark High School. The building was expanded several times, and by 1931, an auditorium, labs, and additional classrooms were added. In 1952, a large cafeteria was added, in addition to more classroom space and a greenhouse. With the construction of a new high school in 1955, the building became Central Middle School and operated until 1981. Taken around 1939, this image depicts the graduating class of Newark High School and was taken on the athletic fields located behind the building. The smokestack of the Continental Diamond Fibre Plant is visible on the right. In 1983, the building was sold to the University of Delaware and today houses the Department of Geography and Spatial Sciences and the University Archives and Management programs.

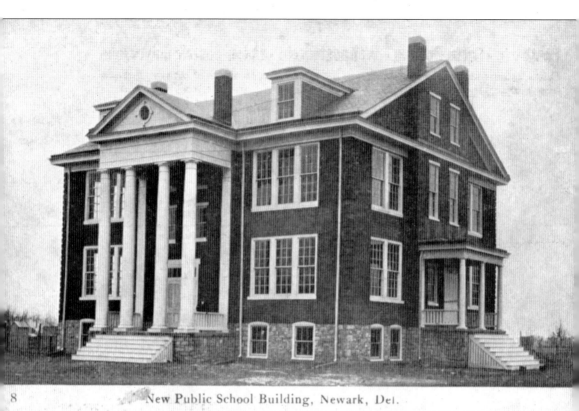

New Public School Building, Newark, Del.

Student enrollment in Newark schools steadily increased throughout the early 1900s. This school opened in 1907 on Delaware Avenue near the southwest corner of Academy Street and became known as Central Elementary. The building consisted of eight rooms, but due to a lack of funding, electricity was not provided to the classrooms. During the 1940s and 1950s, student enrollment increased dramatically, and new school facilities were critically needed. The school building was condemned in 1948 and abandoned in 1950, and a new Central Elementary was constructed on Academy Street that same year. Between 1950 and 1969, the school district built approximately 20 new schools, many of them elementary schools in Newark and on the outskirts of town as residential subdivisions were constructed. Today, the property is owned by the University of Delaware and is the site of the Composites Manufacturing Science Laboratory. (Courtesy of Mary Torbey.)

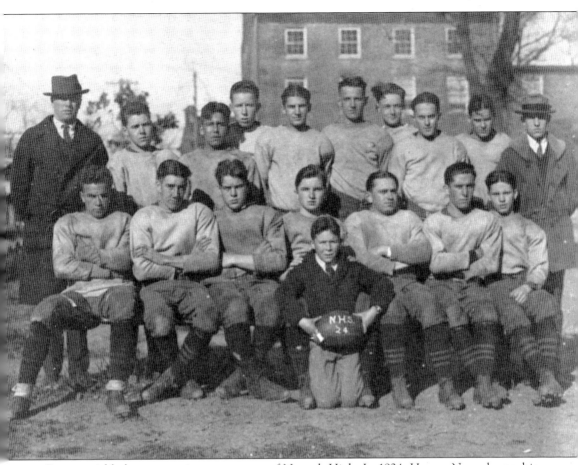

Sports quickly became an important part of Newark High. In 1924, Horace Nunn began his first year as coach of the football team after graduating from the University of Delaware in 1923. Nunn coached the high school baseball team as well. The photograph seen here, posed behind the Academy Building, was taken by Ellis Cullen and depicts the 1924 football team. During this time, all sports practices and games were played in a lot behind Wolf Hall since the university had the only available sports fields in Newark. When the new high school was constructed in 1925, there was sufficient space for the addition of an athletic field. Throughout the 1920s, the Newark team competed in the Delaware Interscholastic Athletic Association (DIAA), which established a championship game to be played on Thanksgiving. The Newark High football team was so successful that they regularly competed in the championship game.

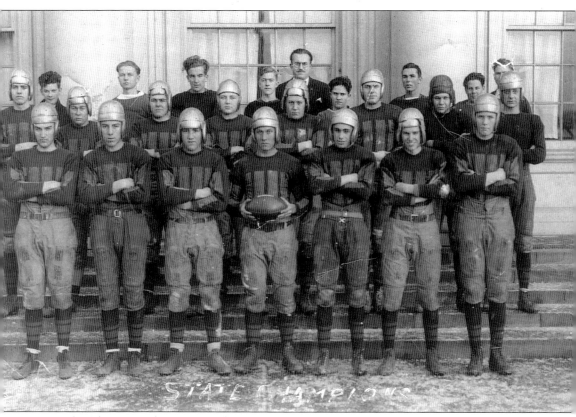

On Thursday, November 28, 1929, the Newark High School football team defeated Seaford High School with a score of 21-7. Members of the team included Frank Mayer as captain and Rip Smith as quarterback. Other team members included Roger Dobson, Harry Gallagher, Paul Griffith, Roland Jackson, Raymond Johnston, Charles Schwartz, Grover Surratt, and Harold Wall. That same year the Newark football team played the highest-scoring game in state history, defeating Smyrna with a score of 114-0. Coached by William Gillespie, the 1929 team had an undefeated season, winning nine games and scoring 156 points while allowing their opponents only 15 points. Gillespie came to Newark High School in 1928 and was made principal two years later. He taught chemistry and physics in addition to coaching both football and basketball and served in these roles until his resignation in 1943.

Basketball, in addition to track and field, was available to both male and female students at Newark High School. Horace Nunn coached the boys' basketball team throughout the 1920s, and in April 1925, his team won the state championship with a record of 12-15 during the regular season. The girls' team for the 1925 to 1926 season was coached by Miss Eggens. Members of the girls' team for that season included D. Armstrong, A. Chalmers, W. Dawson, E. Eubanks, W. Dawson J. Hossinger, E. Robinson, P. Robinson, M. Singles, and D. Stoll. The team won 6 of 11 games but did not reach the championship. Leading scorer Agnes Frazer scored an average of 18 points per game.

This image of the Newark High School marching band and color guard was taken around 1938 in front of the school, then on the corner of Academy Street and Lovett Avenue. The band was formed in the early 1930s with 12 students. At the time that the band was formed, local industries, such as the Continental Fibre Company, also sponsored bands as recreational opportunities for their employees. In 2017, the marching band was nearly cut from the high school's slate of extracurricular activities due to budget constraints but was revived by efforts from band members and an outpouring of community support. The Newark High School marching band and color guard remains one of many student organizations at the high school and plays at football games, performs at local parades and the school's graduation ceremonies, and competes in national events.

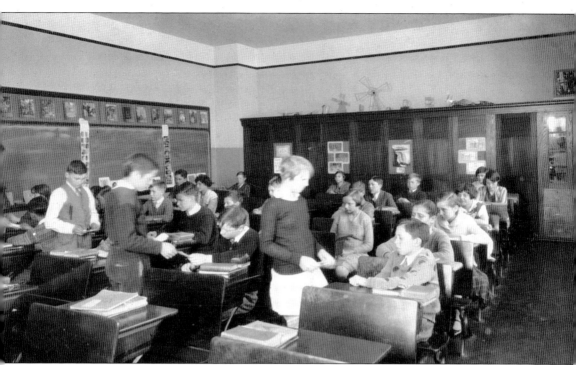

Taken in January 1930, this image depicts Miss McKinsey's seventh grade Social Science class participating in a library session at Newark Junior-Senior High School on Academy Street. In addition to the standard curriculum, students were expected to participate in library sessions, physical education classes, and art and music classes. In 1925, the Newark School District changed the organization of schools from a 1–8 and 9–12 system to 1–6, 7–9, and 10–12. As a result, junior high and senior high students shared the same facilities. This grade structure remained in place until the early 1970s, when the district shifted to K–5, 6–8, and 9–12, with each age group occupying individual school buildings. Today, the Newark School District has been absorbed into the larger Christina School District, which maintains 14 elementary schools, three middle schools, and three high schools.

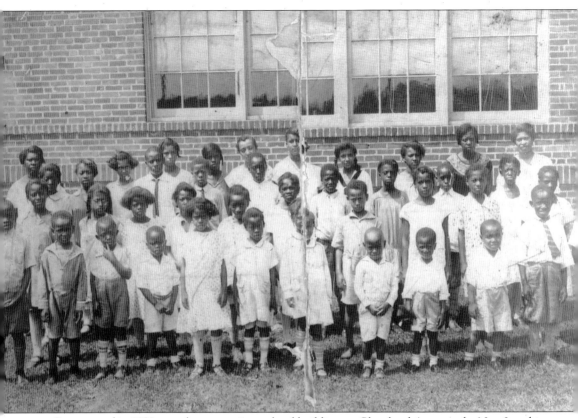

Constructed in 1922 to replace a previous school building on Cleveland Avenue, the New London Avenue School was the only primary school available to African American students. From its construction in 1922 until federally mandated desegregation in 1958, all African American students attended this school through eighth grade. African American students seeking a high school education attended Howard High School in Wilmington. In addition to serving as a school, the building was the focus of the Newark African American community and a meeting place for young African Americans. The building was purchased by the City of Newark in 1961, renovated, and named the New London Community Center when it opened in 1970. In 1977, the building was renamed the George Wilson Community Center to honor a local community leader and member of the city council. The center continues to play an essential role in the community.

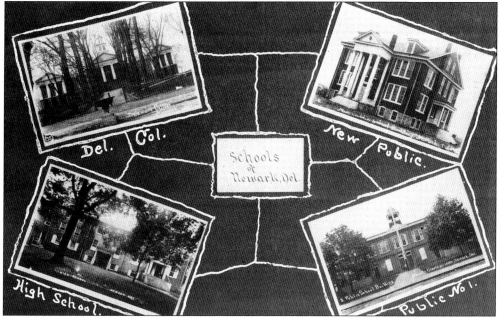

Ed Herbener created these two montages of photographs dating from the early 1900s to document Newark churches and schools and to sell as souvenir postcards. In addition to selling his single-image postcards, Herbener created these two postcards to help increase sales. They combine several of his photographs documenting significant churches and schools in downtown Newark. Herbener included the church buildings of four of the most prominent religious denominations. He represented the four levels of schooling available in Newark at the time: the elementary school, the high school, Delaware College, and the newly-constructed public school. (Below, courtesy of Mary Torbey.)

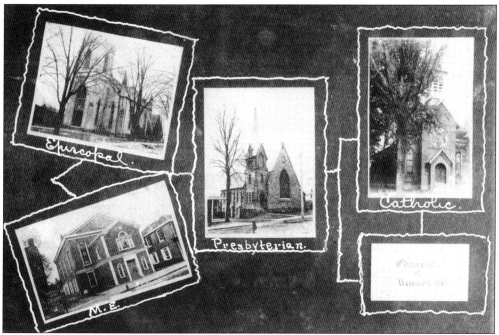

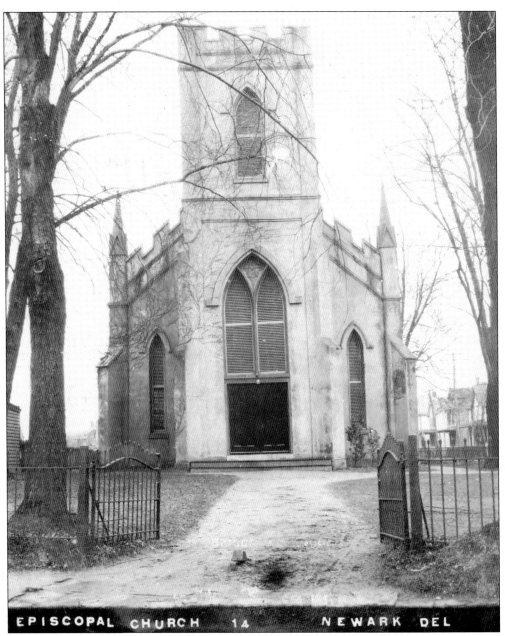

EPISCOPAL CHURCH 14 NEWARK DEL

In August 1842, Newark Episcopalians began the process of organizing a parish after years of worshipping at other local parishes. In June 1843, the property that became St. Thomas Episcopal Church was purchased at the intersection of Delaware Avenue and Elkton Road, and a cornerstone was laid in August of that year. In February 1845, the building was consecrated. The building also housed a lending library during the 1850s, and in 1866, the tower was added. In 1957, a larger church was needed and constructed on South College Avenue. The building pictured here was sold to the Newark Free Library and later to its current owner, the University of Delaware. Renamed Bayard Sharp Hall, today it is used for receptions, lectures, and recitals. The parish also maintains a small cemetery behind it, which originally closed in 1967 but has since been restored and reopened for the burial of cremated remains.

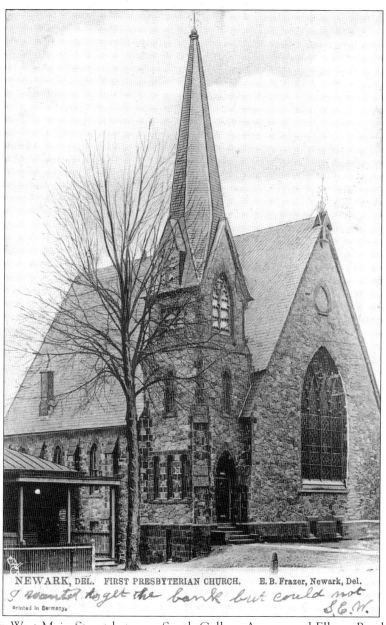

NEWARK, DEL. FIRST PRESBYTERIAN CHURCH. E. B. Frazer, Newark, Del.

I wanted to get the bank but could not S.E.W.

Printed in Germany.

Located on West Main Street between South College Avenue and Elkton Road, the First Presbyterian Church pictured here was built between 1870 and 1872. During the 1830s, two distinct Presbyterian churches developed in Newark, the "old school" and the "new school." The Village Presbyterian Church was founded in 1835, and between 1843 and 1844 a frame church was built on the northeast corner of Main and Chapel Streets. The First Presbyterian Church was founded in 1839 and in 1842 built a church behind what is now 51 East Main Street. In 1860, the two factions came together, and the pictured First Presbyterian Church was constructed shortly thereafter. In 1927, an addition was made to the south facade. In 1968, the church was sold to the University of Delaware, and the congregation constructed a new church on West Main Street. The University of Delaware renamed the building Daugherty Hall, and the chapel is used as a study area in part of the Trabant University Center. (Courtesy of Mary Torbey.)

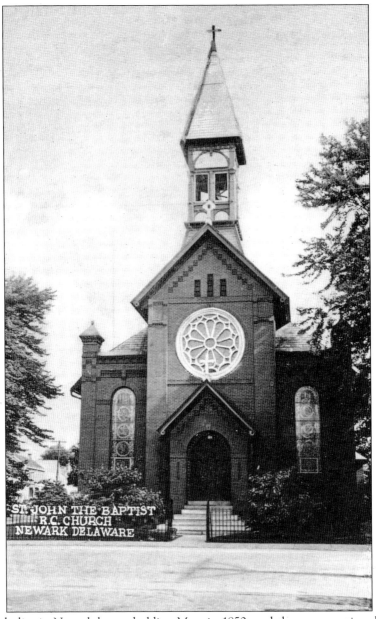

Roman Catholics in Newark began holding Mass in 1850, and the congregation, largely Irish immigrants, organized a parish named St. Patrick's. In 1866, a pastor from Elkton, Maryland, was assigned to conduct Mass in the home of a Newark parishioner once a month until a church building could be procured. In 1868, Charles Murphey purchased the Village Presbyterian Church on the corner of Main and Chapel Streets and donated it to the Catholic Diocese of Wilmington. The church served St. Patrick's congregation until Christmas morning 1880, when the floor collapsed during Mass. While a new church was being built, Sunday Mass was held in the upstairs meeting room of the Newark Grange Hall. The new church pictured here was dedicated as St. John the Baptist in December 1883. The building was refurbished in 1946, and 12 stained glass windows were installed. In 1953, the church's original steeple was damaged by lightning, and subsequently, changes were made to its belfry. (Courtesy of Mary Torbey.)

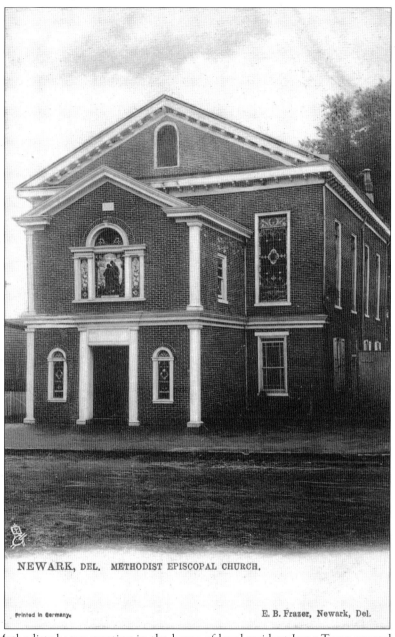

NEWARK, DEL. METHODIST EPISCOPAL CHURCH.

E. B. Frazer, Newark, Del.

Newark Methodists began meeting in the home of local resident Isaac Tyson around 1779, and by 1894, they were served by Pastor Joseph Cook, who included the group on his circuit. In 1811, Tyson began construction on what became Tyson's or Wesley Chapel on land that now comprises the Newark Cemetery, which led to the road near it being named Chapel Street. By the late 1840s, the congregation had outgrown the building, and in 1851, the current property at 69 East Main Street was purchased for the construction of a new church. It was destroyed by fire in 1861. Until a new building could be constructed, services were held in the former Village Presbyterian Church. The building pictured here, erected in 1864 and dedicated on January 8, 1865, is still the current church, but the structure has undergone extensive additions and modifications over the years. (Courtesy of Mary Torbey.)

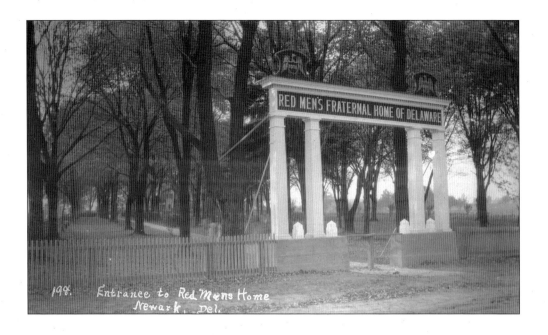

198. Entrance to Red Mens Home Newark, Del.

Residents and visitors to the Red Men's Fraternal Home were greeted by the large entrance sign above and the scenic grove of trees below. Established in Baltimore in 1834, the Improved Order of Red Men was a fraternal organization that emphasized American history, temperance, and patriotism. At the turn of the 19th century, approximately 202 men were members of Newark's "tribe." The daily operation of the Newark Home was overseen by a superintendent and a matron. Residents operated a self-sufficient farm to provide poultry, vegetables, and other goods for the home. (Below, courtesy of Mary Torbey.)

Friendly Greetings from Newark, Del.
152. Grove at Entrance to Red Mens Fraternal Home.

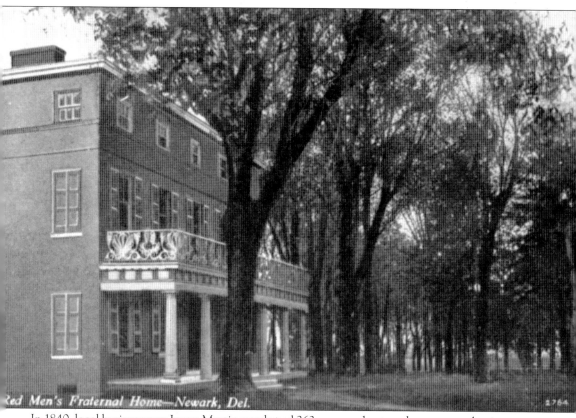

Red Men's Fraternal Home—Newark, Del.

In 1840, local businessman James Martin purchased 263 acres and a stone house near what is now the corner of West Park Place and South College Avenue. Martin had a Greek Revival home built on the property, named the Deer Park Farm, in 1841. The farm was sold at sheriff's sale in 1862 and passed through several owners until the home and 17 acres of land were purchased by the Improved Order of Red Men in 1909. The building was intended to serve as a home for retired Red Men and their wives. Beginning in the 1930s, much of the surrounding land was developed into residential neighborhoods. A decline in the number of organization members resulted in the closure and sale of the home to Theta Chi Fraternity in 1953. In 1971, the building was sold to the Newark Center for Creative Learning, which operated there until 1975. The home remained vacant for many years as plans for development were unsuccessful. The building was razed in the mid-1990s. (Courtesy of Mary Torbey.)

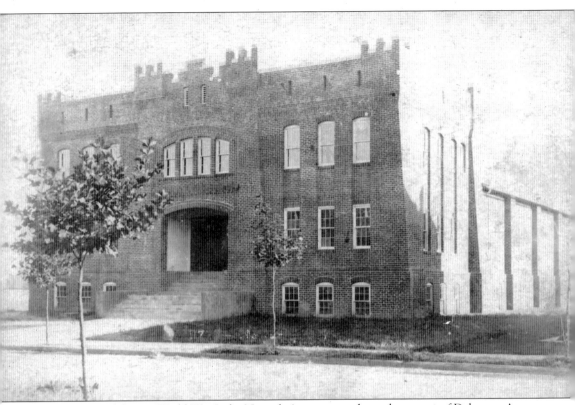

Constructed during World War I, the Newark Armory stands on the corner of Delaware Avenue and Academy Street. In 1916, members of Company E of the Delaware State National Guard conducted drills at the armory. In 1943, during World War II, Newark's National Guard recruits formed Company G and conducted drills at the Newark Armory. In addition to its military function, the building was used by the Newark community for a variety of community purposes, including church carnivals and an annual Merchandising Show and Food Exhibit that allowed local companies and businesses to promote their products. During World War II, weekly USO dances were also held here. Since 1964, the University of Delaware has leased the building from the state, and it now houses University Media Services, including a public video conferencing facility and a television studio. (Courtesy of Mary Torbey.)

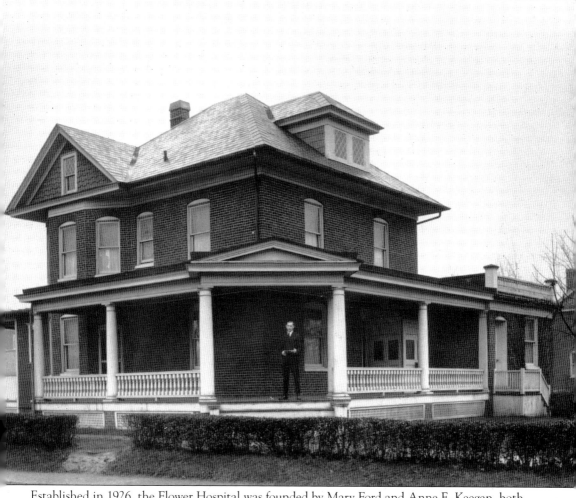

Established in 1926, the Flower Hospital was founded by Mary Ford and Anne E. Keegan, both trained nurses, to provide medical care for Newark residents. Originally located at 172 West Main Street, the hospital consisted of six beds in four rooms. In 1936, the hospital moved to the corner of Delaware and South College Avenues to allow for expansion of its facilities and services. While the hospital was privately owned and operated, it served the public and regularly requested financial assistance from the community to continue operation. The organization relied on annual donations from the town council, local service organizations, fraternities, and clubs during their annual funding drive. Despite the many donations of funds and supplies that allowed the Flower Hospital to remain open for years, it closed in the early 1940s, most likely due to a lack of funding.

The Tuesday Club was founded in 1893 as a women's literary and social club by eight prominent Newark women. The organization met weekly for social gatherings and presented papers written by members. According to the early rules of the club, members were required to compose and present original papers on various assigned topics. Club membership was limited to 25 members until 1898, when the limit increased to 35, but by 1911, membership was unlimited. By 1897, the club had expanded its role to include civic responsibility. The club was renamed the Newark New Century Club in 1900, and in 1917, the organization received a donation of land on Delaware Avenue to construct its headquarters, pictured here. Projects sponsored or addressed by the club include the expansion of the Newark Library, the founding of the Women's College, and the formation of the Welfare Committee in 1920. In addition, the club sponsored social events such as concerts, dances, and other community events, as well as providing a meeting space for club members. While this building was demolished in 2014, the club continues to serve the Newark community. (Courtesy of Mary Torbey.)

As the population of Newark expanded and technology advanced, the establishment of public utilities such as water and electricity became vital. In 1887, a waterworks and water supply system was approved via a referendum vote. Throughout the first three decades of the 20th century, the town council regularly sought approval for funding to extend and improve lighting and water systems, including the construction of an electric light and water plant. In 1932, when the town council proposed constructing its own electric plant, residents opposed the idea in favor of contracting with Delaware Power and Light Company, which would charge a lower rate. (Below, courtesy of Mary Torbey.)

Electric Light & Water Plant, Newark, Del.

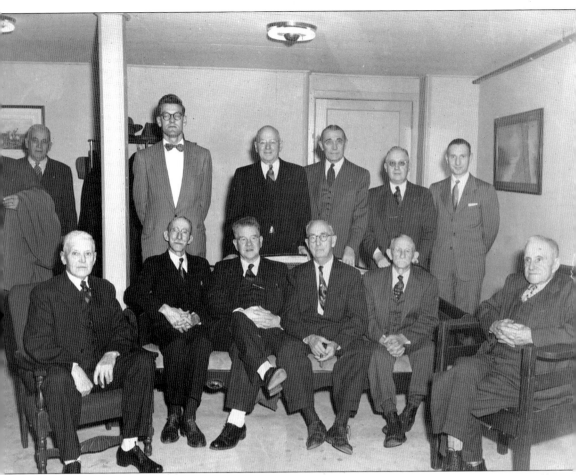

The Newark Lions Club was established on September 23, 1929, when 22 local men were sponsored by the Wilmington Lions Club for membership to the International Association of Lions Clubs. The Newark club became the second in the state and, following the dissolution of the Wilmington Club, is now the state's oldest. Over its almost 100-year existence, the Lions Club has continually served the local community in a variety of ways, including supporting the Newark Welfare Committee during the Great Depression and providing financial support to groups such as the Boy Scouts and Red Cross. In the 1940s, the club established a program for providing eyeglasses to local residents in need. This image depicts the dedication of the Lions Club Old Timers' Room and was taken in the winter of 1942. The Newark Lions Club continues its tradition of service to the City of Newark today.

ABOUT THE NEWARK HISTORICAL SOCIETY

The Newark Historical Society was founded in October 1981, when local historian James Owen motioned for its creation at a public meeting of interested residents, business people, and educators. In January 1982, the first board of directors was elected, with Claudia Bushman serving as the first president. The mission of the society is "to preserve and celebrate Newark's past."

Today, the Newark Historical Society maintains an extensive collection of photographs, documents, memorabilia, and other materials that document the history of the city. In addition, the society sponsors talks, walking tours, and other events promoting Newark's history.

The Newark History Museum, operated by the historical society, is housed in the Philadelphia, Wilmington & Baltimore Railroad station located just off South College Avenue. Originally constructed in 1877, the station was purchased by the City of Newark in 1984 and renovated between 1986 and 1988. In April 1989, the Newark History Museum was opened by the Newark Historical Society in partnership with the City of Newark. The museum curates a variety of themed exhibits of Newark artifacts and memorabilia. For more information, visit the society's website at www.newarkdehistoricalsociety.org.

DISCOVER THOUSANDS OF LOCAL HISTORY BOOKS FEATURING MILLIONS OF VINTAGE IMAGES

Arcadia Publishing, the leading local history publisher in the United States, is committed to making history accessible and meaningful through publishing books that celebrate and preserve the heritage of America's people and places.

Find more books like this at
www.arcadiapublishing.com

Search for your hometown history, your old stomping grounds, and even your favorite sports team.

Consistent with our mission to preserve history on a local level, this book was printed in South Carolina on American-made paper and manufactured entirely in the United States. Products carrying the accredited Forest Stewardship Council (FSC) label are printed on 100 percent FSC-certified paper.

MADE IN THE